Praise for *Painting Your Way Out of a Corner*

"When you have a thought, the value of that thought depends upon how you interact with it. Barbara Diane Barry, the author of *Painting Your Way Out of a Corner*, discovered that her brain was censoring images and ideas as irrelevant or unrelated so quickly that her potential for creative ideas and solutions was crippled. By going through the motions of painting in her journal for six years, she learned to focus on the process of painting rather than the outcome. The more times she went through the motions of painting in her journal the more she found herself interacting with her thoughts. This interaction primed her to explore creative new ways of thinking, living, and reinventing herself.

"There are two ways of spreading light . . . being the candle, or the mirror that reflects it. This book combines both. When you paint in your journal, you are the candle that creates the light that shines on your inner thoughts and fears, and the journal reflects this light to make you aware of the creative choices you must make to navigate through the difficulties of life. This discipline of painting in a journal will allow you to continually reinvent yourself and to learn how to embrace your hidden inner resources—not only for art but for the challenges of life itself."

—Michael Michalko, author of *Thinkertoys* and *Creative Thinkering*

"Barbara Barry has developed an amazing method for opening the creative flow for anyone who wants to dip in and draw from deep water. Writers, poets, painters, chefs, designers, or anyone who wants to work from a creative center can let her be the guide."

—Linda Leonard, Ph.D., author of *The Wounded Woman* and *The Call to Create*

"Some of my most profound and powerful breakthroughs have happened with paintbrush in hand, standing in front of my own wild, intuitive paintings. That's why I'm so delighted that creative souls now have Barbara Diane Barry's *Painting Your Way Out of a Corner* to turn to for guidance on their own self-discovery journeys. Barbara's insightful exercises will help you quiet the inner critic, ignite your intuition, and rev up your innovative problem-solving abilities. So pick up your paintbrush and give yourself full permission to play!"

—Jennifer Lee, author of *The Right-Brain Business Plan*

"Barbara Barry provides a practical and workable solution to the most daunting problem for all those who yearn for self-expression through art: *how to get started*. Her prescriptions for painting as journal-keeping and her imaginative exercises show her skills as a teacher and her respectful empathy for the beginner's fear of the blank page and the inner critic. So often, just getting going is the problem. This book will make you want to jump in."

—BETTY EDWARDS, AUTHOR OF THE INTERNATIONAL BESTSELLER *Drawing on the Right Side of the Brain*

"Much more than just a wonderful guide for learning to paint, this book is a glorious gift to anyone who yearns for a more creative life!"

—MICHAEL J. GELB, AUTHOR OF *How to Think Like Leonardo da Vinci*

"I love this book! It supports readers exploring themselves in a symbolic way that results in true transformation. I am already using it with myself and my clients."

—M.J. RYAN, AUTHOR OF *This Year I Will . . .*

PAINTING YOUR WAY OUT OF A CORNER

JEREMY P. TARCHER/PENGUIN A MEMBER OF PENGUIN GROUP (USA) NEW YORK

PAINTING
YOUR WAY
OUT OF
A CORNER

The Art of Getting Unstuck

Barbara Diane Barry

JEREMY P. TARCHER/PENGUIN
Published by the Penguin Group
Penguin Group (USA) LLC
375 Hudson Street
New York, New York 10014

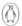

USA · Canada · UK · Ireland · Australia
New Zealand · India · South Africa · China

penguin.com
A Penguin Random House Company

Most Tarcher/Penguin books are available at special quantity discounts for bulk purchase for sales promotions, premiums, fund-raising, and educational needs. Special books or book excerpts also can be created to fit specific needs. For details, write: Special.Markets@us.penguingroup.com.

Library of Congress Cataloging-in-Publication Data

Barry, Barbara Diane.
 Painting your way out of a corner : the art of getting unstuck / Barbara Diane Barry.
 p. cm.
 ISBN 978-0-399-16335-7
 1. Painting—Technique. 2. Painting—Psychological aspects. 3. Artist's block. I. Title.
ND1500. B225 2014 2013030407
 751.4—dc23

Printed in the United States of America
10 9 8 7 6 5 4 3 2 1

Book design by Meighan Cavanaugh

To Katherine,

who never stopped believing in me

CONTENTS

· ·

It may be that when we no longer know what to do we have come to our real work and that when we no longer know which way to go we have begun our real journey.

—Wendell Berry

INTRODUCTION

. .

The Genesis of Journal Painting

It was at the midpoint in my career as an artist and art educator when I completely stopped painting and drawing for a time. It was after a New Jersey women's art collective rejected my membership application because they felt my work did not show a unified style. I was crushed and couldn't even look at a brush. I wondered if perhaps the women's collective was right. It seemed that I just didn't know how to go deeper into my work. I had always been fearful of making mistakes. I would reach a certain level and then back away.

This wasn't the first time in my life when I'd felt stuck. In fact, it had been something of a recurring theme for me for quite some time. At the age of five, I contracted poliovirus, which caused the paralysis of my left hand. That is my first memory of feeling stuck. Not only was I unable to tie my shoes or cut my meat like most kids, for a long time I couldn't even open my hand. I see now how this became a metaphor for me later in life when I couldn't move ahead with a decision or get past some emotional upheaval. As I grew up and became an adult, this pattern played out over and over whenever I approached any task I anticipated as huge. I couldn't get myself to move.

In my artwork I often did not trust the worth of the ideas or images that came to me. I would feel myself freeze up, unable to risk anything. At these moments I imagined myself to be hollow inside, just a big, blank page. When and if some vision arose, I found myself paralyzed with indecision, unable to move forward or backward. If I was working in oils, I'd start scraping away at the images and color, effectively erasing or destroying what I'd done.

The amazing paradox was that even with this kind of self-doubt, I sensed that I had so much more inside me. In my fantasies I wasn't tied to an accurate representation of what I saw or some artistic ideal. Instead I was painting new forms with bold colors and strokes. In truth, I had more to say artistically but did not know how to set it free or even understand what the "it" might be. I was very frustrated and in despair much of the time, and, as I was to discover, this was an immense drain of valuable energy.

Eventually, wanting to keep my hand at some kind of art, I began doodling in a spiral-bound drawing book as something only for myself. I had no plan for any page but used each as a space to let my mind work in a purely spontaneous way, a sort of nonverbal stream of consciousness. I intended the drawing to feel like play, but at first it was more like a tug-of-war as I fought between putting something down on the page and just staring at it.

While I struggled with this on my own, I began to look around to find out what others knew about creative blocks. A fellow searcher recommended a book about creativity and improvisation titled *Free Play*, by violinist Stephen Nachmanovitch. I took expressive painting workshops with Michele Cassou and Stewart Cubley in California, where I discovered the joys of squirrel-hair brushes and reconnected with the thick tempera paint of my childhood. I was inspired by the writings of Joseph Campbell, who urges you to "follow your bliss," and by Carl Jung's ideas about the power of the image. A seminar I attended at the C. G. Jung Foundation of New York called "Creativity: From Process to Transformation" encouraged me to explore active imagination, a process conducive to talking with the images I was painting.

All these experiences I brought back to my painting journal. It was a six-year

journey, and at its end, I came to identify a part of my thinking brain that was judging images and ideas so quickly that I didn't even get a chance to mull them over. As I began to recognize and interrupt this "gatekeeper" operation, I was able very slowly to loosen the mind's grip and interrupt an old childhood inner defense system.

Growing up with an alcoholic parent, I'd learned early to freeze in place, never knowing which way the wind would blow from day to day. The bout with polio also undermined my confidence and ability to know what my body was actually feeling. Both conditions led to a kind of numbness—in both body and mind. Perhaps this gatekeeper had evolved to ensure I was safe—safe from intrusion or from making mistakes, which might cause unanticipated repercussions. Unfortunately, it was an overzealous guard, blocking the way for anything innovative along with the potential threats.

As I continued to paint in my journal, I discovered that the more I learned to focus on the process of art making rather than the outcome, the more I began to see an increased flexibility that affected other areas of my life. It was as if the journal offered me a safe space in which I could explore new ways of thinking, try out ideas and even definitions of who I was, and, of course, work through feelings that were getting in my way. And once I was able to do such things on the page, I found they felt less risky in my everyday life. I was better able to look at alternative career options, for example. I began to risk exploring how I wanted my life and my relationships to proceed. There was a new willingness to put myself on the line, to lean on myself. Even though putting myself forward would always call for greater effort, this emphasis on process over end result gave me the power to stay with something even if there was uncertainty. I had new ways to ride it out, to keep going, to listen for and follow what might come next. I learned to talk to myself and suspend the need to find an answer, any answer to fill the void. And with each successive experience, the next uncertainty became a little easier. I'd found what I'd been looking for. This time, the images, the colors and inventiveness I discovered were not a dream. I'd found the space and the tools I could use to release them into reality. I also learned that this creative process called for a continuous rhythm of reinventing

oneself. There was no one, final reality to find. I had to let go of how I defined myself over and over again in order to discover and embrace some hidden resource within myself, not only for art but in order to meet the demands and adapt to the changes that life throws at us every day. Painting in a journal has remained a discipline I continue to this day.

The Payoff

The answers I've found on my own journey of improvisational painting, as I've learned to transform blocked energy into concrete images, sparked my passion to share the process with others. I wanted to make it available to people who might be searching, as I was. This isn't just about creativity in the arts; it's part of something larger. It's about living and working creatively every day. The creative process exists in all of us, whether we're planning a garden or designing a system at work. Creativity is inherently human and not just for the "artistic," and if nurtured and exercised regularly, it's an incredible tool. While I have been providing art instruction to all ages for over thirty years, I developed and began to teach journaling in images for the rewards of self-discovery it engenders. My hope is that this book will help the reader to navigate the difficult as well as the everyday life choices we all face, as I've seen it do for the students in my classes.

For fifteen years, I've been teaching how to use improvisation and meditation to play with painted images in a very simple and direct way. In that time I've worked with everyone from corporate executives looking to become more innovative and gain a competitive edge to new mothers trying to adjust to an unfamiliar role. Anyone who has left one career for another, become a first-time parent, or lost someone dear to them knows what it means to find oneself at sea, often accompanied by nagging self-doubt and a sense of being frozen in time. Navigating transitions is one of the toughest tests of human resiliency. Our ability to handle change and adapt to new situations requires a skill set not taught in school. Flexibility, risk taking, and

an ability to find options are all things that are necessary for a lifetime of continuous change.

The transitions I have witnessed from my students range from everyday to seismic, including writers and artists conquering their blocks, as well as people making career changes, battling illness or dealing with loss, and going through rites of passage, such as graduations, marriages, divorces, and retirements. I've watched clients at a center for battered women paint with such courage and compassion for others. Still others have used the process simply to get in touch with their creative sides and learn more about themselves and what makes them tick.

As students paint in my class, I am not privy to, nor do I seek to know, the history behind their struggles with perfection, fear, sadness, or whatever limitation may arise on paper. It's enough that we find ways to paint through the feelings and not be blocked by them. Still, sometimes long after the fact, I hear how they have used the painting process to move ahead in their lives.

Lorraine provides art experiences for underprivileged children through a state-funded program. Always looking for new ways to engage them at a deeper, less judgmental level, she decided to take my course to discover her own blocks and felt this would benefit her teaching as well. While we worked on the critical voice that kept her from taking risks on paper, she was working herself toward taking a risk outside the classroom. This painting process helped her find the courage she needed to finally be screened for dyslexia and accommodative and convergence dysfunction. While the vision therapy that followed is physically and emotionally challenging, she finds the best way to release her feelings about it is to go to her journal with a paintbrush and give that frightened little girl she discovered inside herself "everything that she needs."

Carla, a book editor, turned to her journal when wedding planning angst threatened to undermine the coming joyful occasion. Rather than shut down, she painted her way through her negative feelings. At work, she found it helped her jump-start new book projects when she didn't know where or how to begin. The act of painting loosens up her thinking.

Two scientists who came through my studio used the process to "get out of their heads" and find where blocks were holding them back. Jeff learned to breathe his way through blocks and created his own distinctive mantra—"Whatever," always accompanied by a shrug of his shoulders—to help him dive back into a painting when uncertainty kept tripping him up. Doris took the process back to work and used the storytelling aspect of painting to help teach her staff how to explain large and difficult concepts in a narrative way that made them more easily understood.

Diana, an artist and designer, used the painting process to help her cope with a difficult boss while trying to make it to retirement. Later, she used the skills acquired in the studio as she sought a means of survival in retirement. Opportunities were placed in front of her that she thought beyond her abilities. In her own words:

The experiences in the class became examples to remember, not intellectually, but in my body and spirit. I remembered what it felt like to be fearful to continue to paint on a page that I "really liked." What would happen if I ruined the part I just did that I liked so much? What if leaving my job ruined my life? But as I forged ahead with the painting, I felt such exhilaration when a new and exciting image appeared. In the same manner, I find victorious moments occurring daily as I explore the "process" of this new stage of my life as a blank page on which I have the freedom to make mistakes, and turn them into something wonderful that I could never have foreseen as possibilities.

A NEW TAKE ON THE BRAIN

On my journey to develop this painting-journal process, to validate what I was doing, I found myself delving into the new research on the brain and how it works for inspiration. I pored through everything written by neurologist Oliver Sacks, whose work focuses on the strange interplay between body and mind. Over the past ten years, neurological research has done much to shape a different vision of

Cerebrum
The largest of the brain's three main structures

Cerebral Cortex

Cingulate Gyrus

Corpus Callosum

Amygdala

Hippocampus

Cerebrum and limbic system

our brains at work. I have included some of these findings in the book where I think they parallel discussion of the creative process. What follows is background material that will be helpful as you read these science boxes.

The old understanding of the human adult brain as a static and unchanging organ has shifted due to new research. The advent of magnetic resonance imaging (MRI), which pinpoints activity in the brain, has provided a picture of a more plastic entity able to create new neural pathways. Neuroscience deals with the anatomy, physiology, biochemistry, and molecular biology of nerves and nervous tissue. Their relationship to behavior and learning is creating a more contemporary story, to which the ensuing boxes will attest. But first, some brain basics.

Of the three main structures of the brain, the cerebrum, the cerebellum, and

the brainstem, the cerebrum is the largest and the one these boxes are concerned with. This structure is divided into two major hemispheres that work together. The two sides connect and communicate information with each other through a pathway called the corpus callosum. The old story of the brain originally assigned creativity to the right hemisphere alone, leaving the left responsible for logical and symbolic thinking. Through modern functional magnetic resonance imaging (fMRI), researchers are beginning to determine which neurons are operating during some of these brain functions. No longer is creativity assigned solely a right-brain function; rather, it involves the participation of both sides of the brain.

The outer layer of the cerebrum, the cerebral cortex, is also known as gray matter and covers a second layer consisting of nuclei, or white matter. The outer layer is twice the thickness of the inner and is filled with neurons that are particular to humans and give us our ability to think linearly and in abstract systems, such as mathematics. This convoluted layer contains some one hundred billion cells, each with one thousand to ten thousand synapses, and has roughly one hundred million meters of wiring, all packed into a structure the size and thickness of a "formal dinner napkin."[1]

The deeper layer is the part we share with other mammals and is the older part of the brain. These cortical cells make up the limbic system and are often referred to as the emotional or reptilian brain. As information comes in through our senses, the limbic system assigns an emotion to that incoming data. It might not come as a surprise that these emotional functions do not mature as we age. At the limbic level we react to certain stimuli in much the same way we did when we were young.

Three areas of the limbic mind are the cingulate gyrus, which controls our ability to pay attention, the hippocampus, responsible for our ability to retrieve and store memories, and the amygdala. The amygdala, the part you may be most familiar with, is responsible for scanning all incoming stimuli to determine our level of safety (the fight-or-flight response).

Part I

· ·

THE TOOLS

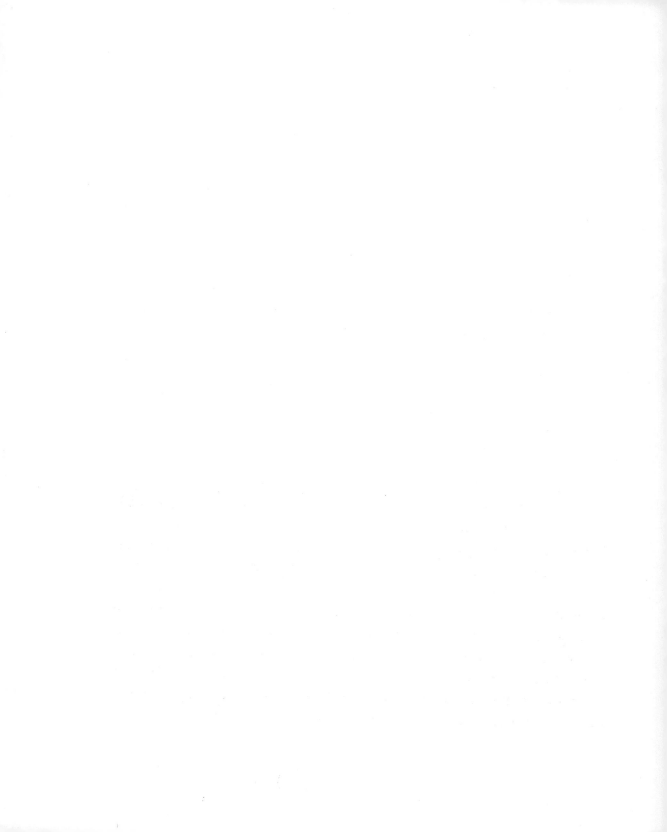

1

KEEPING A VISUAL JOURNAL

Inspiration does not come like a bolt, nor is it kinetic, energetic, striving, but it comes to us slowly and quietly and all the time, though we must regularly and every day give it a little chance to start flowing, prime it with a little solitude and idleness.

—BRENDA UELAND[1]

Painting resuscitated me.

When my second marriage ended eight years ago, I felt as though my life in the suburbs was over too. My children were grown and had already left home. Reminders of a past way of life lay around every corner. I wanted something new with a different kind of energy. I decided to move to Manhattan.

I thought the move would be freeing, but it only made things harder. I suddenly felt adrift. No longer wife or mother of small children, I wasn't sure how to navigate my new status. Even simple decisions challenged me. I found myself paralyzed with fear over the expense of purchasing two large air conditioners for my new apartment. What if I measured wrong and they didn't fit in my windows? What if I couldn't return them and I lost money? Decisions now began and ended with me, and I was petrified I'd make the wrong ones. I was stuck.

And the challenges just kept coming—navigating the subway throng, endless waiting for the bus, and then I discovered the law of the urban laundromat. One morning I had just finished doing two loads in my building's machines when I found that none of the dryers worked. "No problem," I thought and set off for the corner laundromat. But as I threw my wet things into an available tumbler, the manager hurried over, shaking her head. "No, no—only for customer who does wash too." I was dumbstruck. Why such a strict and unyielding rule for something so simple as doing laundry? It wasn't like there weren't empty machines. It wasn't like I wasn't going to pay for the drying.

It made no sense to me, but I gathered up my wet things and returned home all the same. Minutes later, as I draped my heavy sheets around the apartment, I couldn't believe the amount of rage I felt. Unlike in the past when I might have carried the feeling around all day, I took it to my painting journal instead.

I began by painting the forbidden dryers standing on the avenue. I then surrounded them with the soggy garments I had hanging quite literally all around me. When I didn't know what to do next, I put in a few of the trees I noticed out my window. I turned a red drip mark into a large bird only to find him "laughing" at my predicament. Then there I was too, chasing him away. With each new thing I painted, the anger subsided a little more. As I looked to the dirt mound I'd painted underneath the bird, I "found" seeds and out of my brush just the edge of an embryonic shape appeared. Suddenly I began to feel more hopeful. I hadn't lost the day. I wasn't a hostage to my feelings after all.

The process of being creative is a basic means of learning, from playpen to adulthood. As children, we naturally use trial and error to become acquainted with the world around us. As we become adults (and even sooner), we stop seeing "errors" as opportunities for discovery or for the clarity they can bring. Taking chances and making decisions gets complicated by overthinking or trying too hard. Sometimes getting blocked is simply a result of being overwhelmed by too many choices. Logic tells us to sort it out, but just the contemplation of such a task can freeze us into a

Painting my laundry angst

state of paralysis. What we need is a way to clear the interior clutter of whatever is blocking us from taking that first step.

How do we regain that earlier spontaneity and loosen the restrictive judgment that keeps us immobile? How can we release the mind and begin the process that leads to creative solutions? Like a muscle, the creative mind needs to get in shape, be activated and exercised. Because the act of painting is nonverbal and wet, it provides a tool that by nature is limber and direct. Take away the need to make a complete "picture" or any kind of polished result, and you have what I call the unplanned painting, which is a vehicle for improvisation and play, two vital elements of early human development.

The unplanned-painting process described in this book begins with dots and strokes, making a game out of seeing recognizable objects in the shapes you've made. It uses spontaneous painting, that is, making things up as we go along, to access a deeper understanding of our thought processes and actions through visual language.

Painting from the imagination evokes thoughts, feelings, and behaviors that block us in day-to-day experience. Translating them into images on paper tells a story that changes us while also recording the journey. Transformation occurs through the sheer risk of making each dot, shape, or line, and then embracing the result however it manifests.

What I've done is to pair that unplanned approach to painting with the discipline of keeping a journal. The practice of keeping a journal or diary has been the province of kings, presidents, writers, travelers, and rock stars alike. Writing in a journal not only records events, it helps us reflect on feelings and memories. More significant is its potential to prompt users toward new ideas. But, what if words are not your strong suit? Or, what if the workday is already filled with language-driven activities, such as writing, reading, and talking? Visual artists throughout history from Leonardo da Vinci to Marc Chagall have known how to use sketchbooks to play with ideas. The artist Frida Kahlo kept a diary that is similar in spirit to the improvisational process described in this book. In it, she recorded very private thoughts and feelings in both words and imagery. The sketchbooks of filmmaker Tim Burton are a more contemporary example of image making for play, invention, and transformation.

An important aspect of a journal is that it's both accessible and portable so that you can do this anytime, anyplace, and hopefully with regularity, for that is how transformational work occurs best. Like the "morning pages" that Julia Cameron advises writing in her book *The Artist's Way*, the practice of painting on a daily basis opens an inner dialogue necessary for reflection. With painting, this development happens not in a plodding or pedantic way, but almost in spite of itself. By building a habit of playing with paint on paper, we can get at difficult issues that can't be resolved simply by thought and analysis. Each journal page becomes a container, not only for creative exploration, but for release and resolution. Writer Henry Miller, for example, discovered that painting gave him another voice and, at one point, used the process to work through a period of insomnia.

And here's something unique to a painting journal—it's permanent. There's no hiding what's been made, no erasing, and we are encouraged to never paint over

anything we don't like. This gives us a visual record of what occurred during the process—where we were stuck and how we got unstuck—that we can refer to and reflect back on.

How to Use This Book and Optimize Your Experience

This book had been organized to serve two functions. The first is to teach you enough painting technique to attain a certain comfort level with the materials. That means learning a direct and simple use of the brushes and the paints that will invite experimentation. As with any discipline, your level of dexterity will improve with practice. It is not the intention here, however, to achieve mastery of watercolor technique.

The second function is to learn how to access and express personal imagery without censoring yourself. In order to do this, there are several key concepts to keep in mind.

"No Fault" Painting

The first concept under consideration is what I call "no fault" painting—whatever comes out of the brush is good enough. In this process we take the idea of a mistake and turn it on its head. What might once have been viewed as a mistake is now seen as the whimsy of the brush, an experiment or an opportunity to see a mark made on the page from a different perspective.

Self-censorship, whether of ideas or the quality of their expression, is a creativity killer. Innovation doesn't happen in a vacuum; it needs permission to leap about, fall on its face, get dirty, and "keep on truckin'." I'll demonstrate how the inner critic visits in different guises, giving us the chance to practice and fine-tune ways of engaging and moving past it.

Choosing Process over Outcome

Not only are there no mistakes during the act of painting, doing these journal pages will require a commitment toward letting go of the final results. Nurturing a gentler attitude toward our efforts is important as we become familiar with a process in which the gain is not measured by how perfect the product is. The gains are to be found in the experience itself—working every day or as often as possible.

Valuing the process of creating over the product that is created is important because it helps us to see what is happening in the moment by:

- Showing us how we make decisions
- Revealing what stops us or stands in the way of making the next move
- Opening up options and stretching us
- Enlivening the imagination

What You Need Is Already Inside You

The only necessary materials are a few basics like paint and paper; there is no artistic training required to keep an unplanned painting journal and no need to study and draw from objects or living subjects. All the imagery we need has been stored within the intricate workings of the human psyche without any effort on our part. (We'll discuss this further in chapter 9.) From the moment of birth we are drinking in the visual world, and as living, breathing beings we already possess an arsenal of experiences and the sense memories that go with them. Most people only touch upon a fraction of this rich resource in their daily lives. This book will introduce ways to engage with and know your own abundance. When we give ourselves permission to paint from the inside and not for results, as mentioned above, we can access this personal image "library" and take a trip solely on imagination. It is a powerful and healing journey.

Make the Experience Your Own

Everyone will come to this discipline with his or her own level of experience. Some may not have painted since grade school; others may be artists or teachers. While there is a progression of sophistication built in over the course of this book, from simple to more complex, if one chapter or painting exercise inspires you more, start with that. Make the experience your own.

As unique as each person is, there are qualities that equalize the experience no matter who begins this journal work for the first time. If you have bought this book, you are most likely in search of a freer, more spontaneous outlook. You want a tool to assist you along life's journey in a way that moves you forward. That is why I have created this approach and, as I hope you will discover, there is a philosophy behind it that goes beyond the marks made on any one page.

PRACTICE MAKES CORTEX

Studies are showing that practice changes the brain. When we do something over and over, the neurons that control that action fire repeatedly. As they do this, they grow and extend themselves, making connections. These connections or synapses change isolated neurons into networks of intense activity. Not only are new connections possible, but connections that are used less can disappear.[2] How freeing to know that we need not be prisoner to our old habits.

Practicing in your journal doesn't just improve your ability to paint with a brush, take chances, trust your ideas, and increase your playfulness; now science is proving it increases the amount of brain matter you have as well. Researcher Bogdan Draganski and his colleagues at the University of Regensburg in Germany conducted an experiment that demonstrates for the first time that acquiring new

skills changes the anatomical structure of the brain.[3] For this study, Draganski chose a skill that anyone can learn but not easily forget—juggling, specifically, to learn a three-ball cascade. The subjects used in the study were scanned three times to look for changes in brain matter. The first scan occurred at the beginning as a baseline before they were given three months to practice. The second came after they'd learned how to keep the balls in the air for at least sixty seconds. The last MRI screening occurred after the new jugglers were asked to refrain from practicing for another three-month stretch.

The results were surprising. The second scan showed a measurable increase in the density of their gray matter (those outer cortical bumps), which was not in the area the researchers had predicted. Instead of an increase in an area linked with motor skills, the change appeared in "V7," an area associated with visual movement. This still made sense to the research team, as the very skill a juggler needs is to be able to predict where the ball will go after it leaves his hand.

The third scan, taken after abstaining from juggling practice for a three-month period, showed a decrease in the amount of gray matter. Draganski's team believed this to be evidence of the brain's plasticity. Increasing or decreasing gray matter indicated just how efficient the brain is in getting rid of unnecessary neurons and preserving space needed for other new tasks.

"Learning any new skill will challenge your brain," confirms Dr. Arne May, a member of Draganski's team.[4] Any kind of improvisational work such as this painting journal process keeps the practice fresh by constantly challenging our brains to find new solutions and connections between ideas.

THE MIND-SET:
"I" IS FOR IMPROVISE

It is sometimes thought that in improvisation we can do just anything. But lack of a conscious plan does not mean our work is random or arbitrary. Improvisation has its own rules . . . when we are totally faithful to our own individuality, we are actually following an intricate design. This kind of freedom is the opposite of "just anything."

—Stephen Nachmanovitch, violinist[1]

Neither the made-up songs nor the impromptu dances across the family den needed any planning. At age four we didn't think at all; the words and gestures poured out. I see this in my studio all the time. Picture two four-year-old girls painting side by side. The conversation goes like this:

Girl 1: This is the big dirty river. [*She points to a mass of blue strokes running up and down her paper.*]

Girl 2: I'm making a dirty river too. [*She waves her brush of brown furiously around.*]

GIRL 1: There's a giant crab in the river. You have to watch out!

GIRL 2: I'm going to make a bridge to get over that dirty river.

GIRL 1: Me too! [*As she puts the finishing touches on her bridge a new danger presents itself.*]

GIRL 1: But what if you were walking on the bridge and it broke? You would fall in the water.

GIRL 2: Then the giant crab would eat you up!

The girls paint quietly for a while, considering this new possibility. Soon several strokes appear, twisting away from the river, and then . . .

GIRL 1: But if you take the Joy Path every day, you can break the spell.

GIRL 2: Or you'll stay in the crab's tummy forever!

Every Friday these girls would paint some version of the big dirty river story—jumping from paint pot to paper. None of their parents knew where the story came from—it didn't resemble any picture book the girls had read nor relate to a family trip. This was pure imagination. They talked through the entire process, excitedly sharing ideas, keeping the story going between them, adding, changing, inventing. For me, as I watched, it was the very essence of what I had come to trust and teach. The two girls, without any instruction, were enacting a natural process of improvisation.

Over time this natural spontaneity gets compromised. As adults we become guarded, second-guessing ourselves against possible repercussions. It is not that we forget how to play; we just think play only happens on weekends, not in the everyday. We've forgotten how to make believe. We've been educated out of it.

According to author and educator Sir Ken Robinson, an international leader in the development of creativity, innovation, and human resources, we are born knowing how to take a chance. Young children constantly test out their world and invent what they need as they need it. I see this in action as I watch my three-year-old

grandson lay train tracks across the floor. He is trying out all the different pieces—curved, straight, short—until he pulls it all together into various loops for his Thomas the Tank Engine.

Instead of promoting this kind of experimentation and improvisation, Robinson feels our schools teach kids to be afraid of being wrong. These are the very skills resourceful adults need to meet an ever-challenging future. There's a real need to widen our idea of what intelligence means toward a more diverse and interactive approach in order to better develop thinking skills and treat creativity "as important as literacy."[2]

I think people know something is missing and seek ways to improve the quality of their daily lives. The rise in the number of wellness centers that teach how to eat and exercise better, spas that provide massage, meditation, or equine therapies, as well as rehab facilities for detoxification suggest this. But no matter what support a coach, a spa, or a diet plan provides, it will only take us so far. The real work comes down to how we help ourselves once we're alone.

I found the discipline of improvisation to be more faithful and reflective of a person's individuality than most practices. As a tool for generating spontaneity and guiding us toward new solutions and energy, it is always, always, uniquely our own. Whether we choose to engage in art making, writing, acting, or movement, if the activity is unplanned and spontaneous, it is true to our inner, personal landscape. Well, it is, as long as we play by the rules!

"What do rules have to do with improvisation?" you might well ask.

A group or individual engaging in any sort of improvisational form is always bound by an agreed-upon structure to make it work. In traditional jazz, musicians take turns improvising melodies within the chord progression set by a particular piece of music while the others in the group provide rhythm and harmony underneath. In comedic performance, the actors must also work within an agreed-upon format. Following are a few of those guidelines that come from a wide range of notable improvisers, from the professional comedienne Tina Fey (*Bossypants*), to author and essayist Malcolm Gladwell (*Blink: The Power of Thinking Without Thinking*).

The first thing everyone must agree on is to say yes. During a performance, as actors ad-lib their lines, there is an underlying agreement that everyone in the cast will accept everything that happens to them in the course of that play. If anyone responds to another with an inherent or direct no or questions the logistics of a move, as in "That wouldn't happen," the flow is interrupted. Refusing to play with an idea offered by another actor stops all forward movement. In painting, your brush is your partner. Saying, "No, I don't like this shape or stroke," stops the action.

If your mind suddenly hands you an idea for the next detail and you respond with, "I'm not doing it, because it's too silly," or "it's not real," or "it's way too ugly," or "it's not what I want in this picture," then the creative flow stops dead in its tracks. As with the comedy team, everything begins with that initial agreement to be open to whatever happens. In order to engage my students, I invite them to make a contract, first with themselves and then with me. I want them to choose, as much as they can at any given moment, to try a different way of doing something. I might suggest a new way to hold the brush, a reason to refrain from using a drip technique, or that they add a detail they'd thought up but discarded as unworthy.

Another rule of improvisation is to add something to what just occurred. In comedy, that means not being afraid to contribute something to the discussion and not second-guessing your response. In painting, it means almost the same thing—adding something to your visual conversation with the image or stroke you just made.

Though asking questions is a tool I use quite a bit in this book, questions that put up obstacles are not helpful. In painting or acting improv, stopping to ask, "What is this turnip doing here?" fails to keep the ball rolling. It's not necessary to know all the answers—deep, meaningful, or otherwise. Be playful. Better to make it into "the turnip that ate the Bronx!"

Finally, in improvisation there are no mistakes, only opportunities. Wherever the action takes an actor onstage or your brush on the page, that is the way it goes. A slip of the tongue or a slip of the brush will bring accidental discoveries. Do they

all work the way we want them to? Are they all funny, beautiful, ugly, or leading to a neat conclusion? No. And that's all right.

Because this work often demands stepping outside their comfort zone, students naturally put up defenses, thereby intensifying their sensitivity toward suggestions. That's why I suggest using mantras as you paint. (You'll find suggested mantras preceding each painting exercise.) They provide a way to listen and talk to our resistance, and at the same time, respectfully ask it to stand down for a while: "I hear you, but right now I'm going to try it this way instead."

Defenses come into being for a reason. As children we could not speak up for ourselves. We did not have the option nor the ability to say no to anything imposed by outside authority figures. While we need to be respectful of those defenses, as adults they are often no longer necessary. Walking out to the mall parking lot in the dark of night clearly calls for being on the alert, but that kind of scrutiny or antenna for danger has no place in the discovery and play of the painting process. There is no danger to be afraid of here.

Improvisation and spontaneity aren't as chaotic or as random as we think. These skills, like any others, are gained through practice. It takes a lot of practice and repetition to acquire a flexibility of mind and spirit, that willingness to let go of control and be responsive to the moment. Agility is one of the great losses of aging. However, here's a thought: Those who are able to adapt to loss and change can still be successful, trading physical weakness for the ability to reinvent themselves over and over. Forget the antiaging creams—here's the real formula for retaining a youthful vigor.

Finding solutions and making decisions that answer challenges with new vigor depends on our ability to think differently and create more options. We can't do that if we allow our automatic critic to say no to whatever comes along. Spontaneity and unscripted play can lead us closer to where we need to be heading in terms of this decision making, but only if we develop a "Yes! Yes! Yes!" attitude.[3] The old means of problem solving—overthinking, ruminating, or discussing with friends or family

which is the best course to take—does not always serve us. In fact, it often leads us astray or confuses us further. Improvisation provides a fresh and viable alternative to finding solutions not yet tried. It is with an improvisational spirit that I hope you'll approach this painting process.

YOUR BRAIN ON IMPROV

Charles Limb is an otolaryngologist at Johns Hopkins University, but he's also an accomplished musician. Currently he is using imaging equipment to map creative juices as they flow through the brain. That musical avocation is undoubtedly why he and collaborator Allen R. Braun, another music enthusiast, began to study the brain activity of jazz musicians.

Limb and Braun decided to look at what the brain was doing as jazz musicians composed improvised riffs. The tested subjects played on a modified keyboard while lying in an fMRI machine. Research shows that when jazz musicians improvise, their brains turn off areas linked to self-censoring and inhibition, and turn on those that let self-expression flow. Another result of note is that brain areas involving all the senses also lit up during improvisation, indicating that the musician is in a heightened state of awareness, much the same as that seen in REM sleep. Braun feels there may be a connection between the patterns of both spontaneous acts, dreaming and improvising. The trancelike state of the jazz musician as he goes into his riff is like wakeful dreaming.[4]

While this study focuses on musical improvisation, this type of (creative) brain activity is crucial for life outside music as well. People are continually improvising conversational speech, coming up with solutions on the spot. "Without this type of creativity, humans wouldn't have advanced as a species," says Limb. "It's an integral part of who we are."[5] Limb hopes to study the brain during other art forms such as writing and painting. Meanwhile, the research is clear: Silencing our inner critic leads to improvisation, which is critical for enhancing creativity.

Preparing Yourself to Paint

As I've mentioned before, in order to foster the necessary openness to allow for self-discovery, we need to create an atmosphere of acceptance—not judgment. Therefore the place where we do our creative work needs to be free from the eyes and interruptions of others. Even well-meaning comments from family and friends can easily distract us or make us have second thoughts about a direction we're going.

I am reminded of a friend who visited my studio and was looking around at some of the work on display, when she suddenly stopped in front of a painting of a very large and red wailing woman surrounded by blue devils. "Oh," my friend cried out, "that one upsets me. I can't look at it!" She had no idea, nor did I tell her, that it was a self-portrait and that I had tender feelings about it. Still, I felt a little crushed and determined thereafter to be more careful about what I left out for the eyes of others. If I had been working on the painting at the time, I might not have finished it or might not have felt free enough to go as far (and as red) with it as I did. My responsibility, not hers.

What you create in your painting journal is just for you. Even the idea of sharing with others can limit the sense of the spontaneity and freedom you feel when you paint. The first step in this process is not to put paint on the paper; the first step is to set up an environment where you have the best chance of being productive. The following are some other ways in which you can do that.

Building Your Work Area

Choose an out-of-the-way area. If space is a premium, carve out part of a closet or set yourself up in the corner of a room off the beaten path. If privacy is a challenge, choose to work at a time when activity about you is minimal. The beauty of the journal is that it does not take much space and can go anywhere. Know what inspires you. Natural light for me is a must. In winter I work at the kitchen table by

the window, while in summer you can often find me out on the terrace or traveling with my journal in hand.

Creating a Sacred Space

In my studio classes I've borrowed the idea of *temenos* from both the Greeks and improvisational violinist Stephen Nachmanovitch. This Greek word means "sacred space" and, according to Nachmanovitch, within it "special rules apply and extraordinary events are free to occur."[6] I like that. After all, this kind of improvisational painting cannot be done just anywhere. We are creating an unusual setting. It may be helpful to hold this idea of a sacred space in your mind as you prepare to "enter" your place of exploration at home.

Quieting the Mind

This is a kind of meditative discipline; most such disciplines require time to settle down and concentrate. The mind is on an endless mission of errands. To-do lists fill our days with the minutiae of life. Buddhists identify this state as "monkey mind," a swinging from thought to thought. Creativity needs freedom from inner intrusions as well as outer ones. Give yourself enough time to enter a level of solitude and peace before you begin to create. I usually find that setting up my materials is my ritual, not only for preparing to paint, but for readying my spirit. It's done quietly, with attention to detail. The table must be cleared of everything and cleaned. My brushes are held in an old glass mason jar so they make a tinkly sound when moved. Set aside at least an hour for each painting session to start with if you can.

Silence Is Golden

One of the first hurdles my students often face is learning to accept the silence. Although music would minimize the tension, I do not succumb to turning on the

radio, and with good reason. We live in a world of endless streaming stimuli, sometimes invited, but, more often than not, unwelcome and without any choice on our part. (Think Muzak in the elevator.) Music is a great swayer of emotion. It can lift us up or it can surprise us by the sudden triggering of some forgotten sorrow. In this painting process, we take special care to let images and any ensuing feelings emerge in an organic way from within ourselves. That means a gentle approach, guided by inner intuition, rather than by some outside influence.

Eye of the Beholder

The way we think, look at, and talk about our work matters. Staying curious and being kind toward our efforts will foster the spontaneity we seek. After each exercise I provide thoughts and questions to ponder what you have just done. The intention is always to reflect on the process of the exercise and not the outcome. The challenges that arise each time we paint—what to do next, how to work through a block—will solve themselves if we can get the critical voice out of the way.

Now Breathe

One way to quiet the mind is a simple one-minute meditation. Use one you know or the following suggestion: Sitting upright in a chair, begin your studio time with a few cleansing breaths. Close your eyes and take a deep breath through your nose, reaching down from a relaxed belly, and let it out, slow and measured, through your mouth. Do this at least three times. Follow with normal breathing, eyes still closed, keeping your mind blank and focused on your breath until you're ready to begin your page.

3

GETTING STARTED

What I hear, I forget
What I see, I remember
What I do, I know

—CHINESE PROVERB

When I first began my visual journal, I tried a variety of dry media that I happened to have on hand—black marker pen, colored pencils, and oil crayons. I deliberately eliminated pencils in order to keep from "sketching" my ideas. To choose an erasable medium seemed to encourage correction rather than improvisation.

It was when I began to use watercolor paints, however, that I found the looseness, flow, and sense of play I was seeking. The wet medium allowed for happy "accidents" beyond what the eye, hand, and brain together could produce with intention. Of course, I didn't always like the results, but there was no going back, no wiping them away or covering them up. The only way to proceed was to follow where the images would lead me, adding details and bringing imagination to what had appeared on paper.

I chose simple materials of good quality for several reasons. I wanted to get away

from materials that implied art with a capital *A*. Media such as oils or acrylics, most of which come in tubes, are not easily handled and have attributes that call for painters to have more technical training. I also feel they suggest something precious, a world in which paint must be used sparingly and paper must not be wasted. (Implication: "Get it right the first time!") In our practice, we will use as much paint as we need and paper is for experimentation. Take time to familiarize yourself with the materials as a step toward the development of a relaxed but focused approach. Let the meditative aspect of this work begin with the setup and care of the tools.

Knowing the Materials

The Watercolor Paint Box

The paints are in cakes, not tubes, so mixing is unnecessary. Mixing colors can be fun, but for the untrained it may lead to frustration when the desired color does not result. Even for experienced artists, it can distract from the process. We do not need to seek the "best" color, only one of the twenty-four. Mixing is something that can be incorporated at a later time. Right now we want everything to be accessible and direct. Some paint boxes contain a tube of white paint. Set that aside for now as it invites covering up or mixing, or both. We will come back to it later in the book.

Watercolor Brushes

> 1 squirrel-hair watercolor mop, size 1
> 1 or 2 sable short-handled brushes, sizes 1–2

The larger brush is called a watercolor "mop." I like it because it is very responsive to the pressure applied to it, like the *sumi* brush used in Asian calligraphy. Apply

pressure and you will get a wider stroke. Ease up and the point makes its own delicate squiggle. The best mops are handmade and are quite expensive. You may want to treat yourself to additional sizes at some point, but for now, the one suggested on page 165 is of good quality and will supply the effects we want.

The most important thing to know about using this mop brush is that it needs to be wet and should never be used in any dry scrubbing motion. Before you start painting, feel the tip of the brush against your hand. Notice how soft it is and how the point softly springs back when you run your finger over the top. In the painting process if the bristles separate and get spiky, it means the brush needs a drink.

The second, smaller brush has a tighter bristle head that's not as flexible as the mop brush, and for that reason, it's better for more detailed painting. It does not hold as much paint as the mop, so you'll have to go back to your paint palette often. You might also want to have two different sizes on hand—the smaller the brush, the finer the line and the smaller the details to be added.

To clean your brushes at the end of your painting session, simply rinse with tepid water, never hot. Once in a while, clean them with a mild soap to get out any residue pigment.

Spiral-Bound Watercolor Book

Acid-free watercolor paper, 140-lb. cold press
Start with 10" × 7" size, but vary it up or down later as desired

Although good drawing paper would suffice, I've found that watercolor paper provides enough of an increase in satisfaction to justify the extra cost. The texture or "tooth" of this paper increases contact with the brush, making the painting experience much more tactile. The weight of the paper also means it won't buckle.

The 10" × 7" book is a good size to begin learning the process. It's not so large as to be intimidating, but large enough to move around in and fill up quickly. As

you gain confidence and experience, you may choose to give yourself more space and move up to a larger size.

Setting Up

You will want to arrange your materials about you so that there is an easy flow from water to paint to paper. I have provided a sample setup below, but you will need to experiment to find what works best for you.

Water container: choose a widemouthed container for cleaning the brushes.

Brushes in a cup or jar

Paper towels: I use these to blot my brush when cleaning between colors to check if the color is out.

Table cover: I like a large sheet of white paper underneath my setup, covering my work surface.

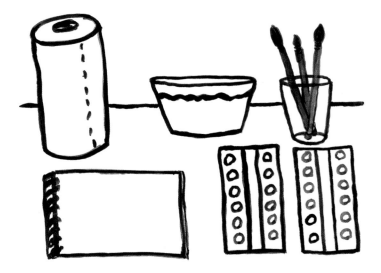

This is the setup for a right-handed person. I like to keep all my tools to one side, so paint and water are less likely to drip across my page.

The Journal Pages

You will use both sides of the page. When I first started working in watercolor books, I used only one side—as any watercolorist would—thinking that if one of my pages was really good, I might want to remove it from the book and frame it, thereby losing anything painted on the back. Then it suddenly hit me what I was doing. This way of thinking was totally at odds with this new process and its purpose of letting go of results. So I let that go too and began painting front and back.

Jot down the date at the end of your painting session—somewhere on the bottom corner of each new page—rather than at the beginning. This way you don't have to worry about covering it up as you work.

Exercise Introduction: Approaching the Blank Page

As you open your notebook to start your first journal page, there are a few things to keep in mind.

A Word about Mistakes ("No Fault" Painting):

There aren't any. You're working from the imagination, so everything that occurs can be seen as a new possibility, not a wrong turn. That doesn't mean you will always feel that way about what you paint. In fact, negative feelings are going to arise over and over, so you'll get lots of opportunities to practice developing a more patient and gentle response to those "Oh nos!" You may even experience the urge to cover up some disappointing result or tear out the page and start over. Resist the impulse. Notice it but don't trust it. This has to do with conservation, not of paper

but of your own energy. Let's take that destructive impulse and transform it into an image instead.

Blank-Page Anxiety

Students can often be unnerved by the empty white paper before them. I know teachers who have students poke a hole in the paper ("Can't possibly ruin it now!") or invite them to paint the surface a solid pale color to ease any anxiety. Notice that the pages of this journal are not very big. It's not going to take a lot to fill them. Remember too that this is not about learning to be an expert artist, just a playful expressionist.

Exercise: Do a Dot

One of the basic strokes in Chinese brushwork is the dot, which is called *dianfa* when creating dots in a grouping. The simplest and most basic of shapes, the dot in time will become your best friend when you don't know what to do next. So let's use the dot as you try out your paint palette and get the feel of the brush. The intention here is not to "do" a painting or make anything look like anything else. We are doing what one of my past teachers called "making friends with the brush."

From the very start, it is important to avoid getting hung up on choosing a color. In time you will use them all. In this process, the colors are equal in value because our focus, at all times, is to keep things going and not let anything interrupt the flow, especially not the search for the "perfect" color. The easiest way to circumvent this potential block is to simply go for the first one to catch your eye.

In this exercise we will start with the mop brush and add the small-detail brush shortly.

Sample Mantra: "There is no perfect color."

1. Hold your brush as you would a pencil. In this painting process we are using the brush as a drawing tool. Holding the end of the brush is painterly but to my mind puts too much distance between you and the paper. We seek engagement and intimacy through contact and touch.

2. Wet your brush and dip it into the first color to attract your eye. Using a circular motion gently press the water into the pigment, being sure to get it up into the bristles of the brush. Because the brushes are brand-new and the palette is dry, you may have to rewet the brush and the color. We want to saturate the bristles with pigment, keeping the color bold.

Hint: As you test out the materials, you'll discover that the amount of water you use affects the intensity of the color. The more water, the more diluted and washed-out the color. For now I suggest using a limited amount of water. This keeps the colors bold and avoids getting the paper so wet that everything runs together or off the page.

3. With your full brush, slowly plant some dots on the page using just the tip of the brush. Then make some dots by pressing down with the whole brush head. It is not our intention to make perfect circles with our "dots." Just apply varying amounts of pressure to create more natural circular or oval-like shapes. If you have ever seen Chinese watercolor paintings, think about the dots in those as you paint.

4. Change colors as often as you want, making sure to clean your brush in between and wipe off excess water on the edge of your water bowl.

5. Using your detail brush, add smaller dots inside larger ones that have dried. As with the mop, get the paint color wet, mixing with a circular movement to get the color up into the bristles. You will notice that you have to keep going back to the paint for more color.

Some other things to try:

- Place new dots alongside your first ones or paint them in groups.
- Make a trail of "footprints" across the page.
- Go back over a painted dot that has dried with the same color. Notice the change.
- Place light-colored dots next to dark ones, or try all the different blues in one area.
- Try joining dots together by placing them side by side to create a new or bigger shape.
- Add some lines to group dots together.

Notice how dots placed close together can create a feeling of movement.

Reflecting on Your Work

How did the brush feel in your hand? Like a stranger or an old friend? It may take some practice, but this brush is really user-friendly and fun. Did you notice a difference in how certain colors made you feel? Which ones did you think were yummy? Was there a color you didn't like or one that felt too strong in an unpleasant way? Reactions to color are a very subjective experience. Luscious spring green to one person could be just plain bilious to another.

THE POWER OF A DOT

A fundamental concept in Gestalt psychology is the idea that an organism tends toward a state of equilibrium. When a disturbance occurs to upset that balance, the organism works toward reestablishing equilibrium. We can see evidence of this in the physical world with objects that tend toward a resting, stable state. Look at a drop of water splashed onto a tabletop, for example. It will draw inward and come to rest in a circle. Gestalt psychology studies how the human eye organizes visual experiences and how the brain then interprets what it sees. According to the Gestalt principle of equilibrium, we look for stability in all we observe.[1]

Designers often borrow ideas

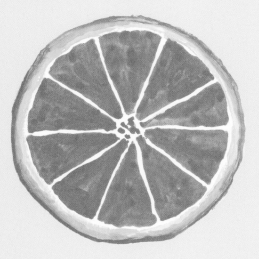

Cross section of an orange

from Gestalt theory to create compelling visuals, and they understand that when we paint a dot, we are imitating nature and creating equilibrium too. As with the droplet of water, our eye is drawn to the center of the dot, and the brain tells us there is no tension here. It is a balanced shape. Other examples of this kind of equilibrium—where your eye is pulled toward the center, a restful place of an object—include a daisy, the human eye, and a slice of orange. Can you think of others?

It is no wonder then that painting dots is an activity that is restful while helping us to keep the momentum going.

4

COLORING 101

I was alone and singularly free, working into my own unknown—no one to sat-
isfy but myself. I began with charcoal and paper and decided not to use any color
until it was impossible to do what I wanted to do in black and white. I believe it
was June before I needed blue.

—GEORGIA O'KEEFFE[1]

One of the most attractive and engaging things about this painting process is the chance to work with a wide range of colors. When students enter my studio for the first time, just about everyone is transfixed by the paint table, lined end to end with twenty-four cups of graduated hues—yellows, oranges, reds, magentas, blues, greens, and purples. Almost instantly, no matter the age of the visitor, I hear the inevitable, "Oooooh." (Remember your first box of Crayola crayons?) In my journal class I see the same delight as students crack that new box of watercolors for the first time.

Because we want the painting process to be as easy and direct as possible, any-thing that stops fluidity is suspect. Mixing colors or diluting colors to get a lighter tone, while it might feel fun and loose, can also become distracting, taking the painter out of the moment, away from image making and a more spontaneous

engagement. Students new to the medium can easily get frustrated by trying to create new colors. If you've never learned to begin a mixture by adding darker tones to light instead of vice versa, colors invariably end up too muddy and dark. Even those with more experience can get sidetracked creating endless and sumptuous varieties only to get very little paint to paper.

That doesn't mean you can never mix, just not in the beginning. The question goes to one of intention. Are your actions taking you further into the painting process or out of it? If you are playing and experimenting, trying two colors together and then adding them to your painting, then you are staying in the flow.

If instead you find yourself unsatisfied with the result of the experiment and begin mixing anew, then you've gotten sidetracked. Your main focus should always be putting marks on the page. That's where the action happens—on the paper. Not being satisfied with your color choices may be a sign that you are unable to decide what to use. You may be waiting for the "perfect" color to call instead of simply opting for the one the eye falls upon first. This particular block is quite common. It goes back to the fear of making a mistake and the idea that somehow there is a "best choice" to be made.

This might serve us if we were studying color theory, but we're not. Among the twenty-four colors in your paint box, there is one that will do in the moment, especially this early in the game. The focus is on forward movement—whatever takes us to the next step. There is a tendency to rely on the eye for some kind of "truth," when seeing is really a perception affected by experience and history. The eye is making a judgment and it may be misinformed.

As a teenager I remember having a reverse prejudice against pinks and purples. I didn't want the typical girly room—all pink ruffles and purple florals. My bedroom was to be a den, an office, a studio. The value I put on those colors extended into my adulthood. I never wore the hues, never dressed my little daughter in them or used them about the home, although by this time it was no longer a conscious choice. It wasn't until I began painting spontaneously that I discovered the excitement of purple tones next to red ones, or appreciated the subtleties of creamy pink

paint, lush like bouquets of snapdragons or cherry blossoms. You just don't know until you've tried them all.

I want students to start off with the experience of painting bold strokes of saturated color rather than trying to work up to this. This means getting lots of color into the bristles and using only enough water to allow your brush to glide across the paper. If you are watering down most of your colors, you might ask yourself, "Is it because I only like pastels or because when the image is lighter it seems safer, not so noticeable?" You may feel that the lighter color affords you the chance to fix something or change it if it doesn't come out right.

If I seem to be making a big deal out of this, there is a reason. Many new students will tell me they want to use only "happy" colors, which they believe will guarantee them a happy picture. Unfortunately, that's a myth. Picasso for one period of his life worked from a rich palette of pastels, but most of this work wouldn't be called happy. (His Harlequin series comes to mind.) While we certainly all have color preferences—just look in your closet—this idea reflects a certain aesthetic judgment we are not born with. We have learned what is considered pretty and what is deemed ugly.

While taking an independent-study course at a local college, I had occasion to observe a group of kindergartners at the easels painting pictures. Afterward, the teacher sat the children in a circle while she held up each picture for what turned out to be her "critique." All the papers were filled with various splashes of the rainbow, except one, painted by a child who had used only black. The teacher's next words are forever imprinted on my brain. "Black is not a color. We don't like black, do we?" Like any other kind of prejudice, color bias can be taught. This class, by the way, was from an inner-city school and most of the children were African American, adding insult to injury.

The intent is always to be open to what is happening in the moment and embrace the whole experience, not holding ourselves back out of a need to be . . . safe, perfect, neat, pretty, competent (you can insert any ideal here). The ultimate goal is to express ourselves, but in an organic and fluid way, not in a forced or clutching way.

One way to strengthen our spontaneous responses is to allow all colors to have equal value. The moment we start asking ourselves which color would be better, or even best, for that next thing, we've created a hiccup—the flow of air (or paint) stops. If it takes longer than a second to grab the next color, then the critical brain is going to dig its toes in and take over. The momentum is lost.

In the beginning of this discipline, one of the goals is to notice how you interrupt yourself. You have to recognize how the hiccups happen before you can change them. One of the first ways I see students check themselves is at the paint table. The brush may go toward the brown (or red or yellow) only to stop, hesitate, and then go to another color. While it seems only a minor break, it's the small actions that signify larger ones. Small actions often reveal how our brains work in ways we aren't even aware of. And it's easier to see and change the small things.

For example, when I was first trying to improve my ability to start or finish projects, I didn't begin where I had most to lose. I began by changing very little things, things I always put off—picking up my dry cleaning or sewing the buttons back on my coat.

If there really are no mistakes, then it doesn't matter which color the brush chooses. Why not trust the one we choose without deliberation, the one the hand just seems to seek out on its own? This is that nonverbal part of our being as it gets a chance to speak our intuitive nature.

This will take practice. Begin by noticing when you edit yourself and then try to trust your instincts by staying with your initial color choice. Some other ways to keep from simply staring at your paints are to start at one end of your paint box and work your way to the other. Or close your eyes for a moment and then go for the first color you see when you open them. It just doesn't matter which one you use. Like the expressive and accidental slip of the brush, using a color you didn't intend creates excitement.

Elaine was painting a tree when she suddenly seemed to run out of steam. I found her standing over the paint table just staring down as her hand hovered over one color after another, unable to make a selection. She couldn't decide which color to add to

the basic brown of the tree bark; she only knew she wanted to "jazz it up" in some way. The right color wasn't presenting itself to her eye. "So stop looking," I suggested. "What if you let the paint decide for you and use the color closest to you right now?"

The closest color was magenta, hardly anything she would have considered as a tree color, but as she began using it, adding short barklike strokes on top of the brown, she began to get excited by the vibration the two colors created in proximity. Suddenly the tree had new life and energy and she was back in the flow.

Holding to what we think is the right way or what we think may be more realistic can keep us from learning through doing. Elaine's worry over color choice stopped her from moving forward. Step outside logic and we may discover the real value and vitality of color and also a bit of truth about the natural world. All tree bark is not plain brown.

By jumping around on your palette, you may suddenly connect with a color as you put it to paper, and like Elaine, luxuriate in its lushness. You may find you can't put enough of it across the page. Work with the color as long as you feel engaged. As soon as your mind starts analyzing what's happening or you stop painting, choose another color. The "dance" from brush to water to color to paper and back again keeps your engine going. The actual physical energy involved increases neural transmission, the kind we want. Move your brush, move your mind. When your energy is up, your focus is better and the moments flow more easily one into the other.

Exercise Introduction:
Your Inner Palette

We may think we already know which colors say, "This is me," or "This is not me." Through no fault of our own we have picked up the usual and subjective connotations associated with certain hues, as I mentioned earlier—blue is sad, or green stands for envy. This suddenly takes me to that awful scene in *Mommie Dearest* in

which Faye Dunaway (as Joan Crawford) shouts, "No wire hangers—ever!" Or make that "No brown paint—ever!"

We may have strongly held injunctions against some colors, which can interfere with experimentation and making new discoveries. Why such a taboo?

During a mural project I facilitated to help a group of consultants create a sense of community, some of these same questions arose concerning color preferences. Karen was disappointed when in the course of her work she had to trade her container of peacock-blue paint for the light gray. She worked with it anyway but was glad enough to trade it away at the first opportunity. A similar feeling arose when Joan got the black-paint pot. Later, as the group discussed their aversions to certain hues, we looked to the completed canvas for enlightenment. Karen had felt using gray was wasted effort when there were so many other bright hues to choose from. But, by examining the canvas, we were able to see how the use of gray enhanced the overall design, making other colors pop in contrast, while the black paint seemed to create drama by making "frames" around some images.

As you use and familiarize yourself with the colors in the next exercise, keep in mind that's all you are doing. This is not about "making" anything in particular, but having another chance to see what the colors actually look like. It's less important whether or not we like them or think they go with the colors next to them.

Exercise: Miss Cunningham's Rainy Day Lesson

Coloring books were pooh-poohed back in the 1980s by educators and parents. (Remember *The Anti-Coloring Book*, by Susan Striker?) They were considered by some to be an uncreative form of expression for young ones. But I can still recall a certain satisfaction I experienced as a child filling in black outlines with exotic Crayola hues (cornflower or Prussian blue, for example). I also loved how it felt to lean into the pad of soft newspaper pages beneath my crayon. So much of memory is sensory.

The following exercise is taken from something my grade-school art teacher used to let us do (when we begged). I'm sure she felt it wasn't creative enough, but we loved filling in the areas with thick waxy color. Kindergarten is always a good place to inspire creative play!

Sample Mantra: "Nothing has to be difficult. I'm just playing."

1. Use your mop brush and black paint to make a simple scribble design of lines.
2. Fill in two or three of the enclosed shapes with black pigment.
3. Fill in the rest of the areas with other colors. You may choose to make them all different or you can repeat colors, but include some darker hues like blue or green.

Let your brush wander all over the page. Then fill in the shapes that your lines have made with black and some other colors.

4. Once a colored-in area is dry, try painting on another layer of the same color. Note the change and repeat if desired.

Hint: Once again, keep reloading your brush with color to ensure the color is deep and not washed out with too much water. Change back and forth between the mop and detail brush as needed.

5. Now add some small shapes to one of the black areas, making some of the dots from our last exercise. Try making them in a light color and then in a dark color on different backgrounds.

Add small shapes and lines to the black and colored areas.

6. In the second black area, add some lines—they can be straight, wavy, or zigzag. Try a light color, then a darker hue.
7. Add some repeated shapes (dots, stars, triangles, etc.) or lines to one or two areas using the black paint.

- Do you see any other colored area for further decoration? What about adding more black outlines to fill in?
- If you put smaller shapes or lines inside another shape, can you keep going with your design? How much smaller can you go?
- Is there something you did that you would like to repeat or make more of?

Paint in more color and shapes.

Reflecting on Your Work

How did it feel to build up layers of one color? Did one part of the exercise feel easier than another? By now, you may have noticed how the black outlines act like the lead in stained-glass windows (French expressionist Georges Rouault was known for using this in his paintings) by separating and distinguishing the colors from one another. You may have been excited by the vibration some colors made next to each

other—red and green, for example. Most important to note is the satisfaction you likely felt when filling in shapes and making up details without worrying about what you were doing, just finding ways to keep the dance between color and shape going as long as you could.

THE MAGIC OF CRAYONS

Not only did I love coloring inside black lines, I also spent hours drawing my own creations, often as stories for the amusement of my much younger sister. Happy colors aside, I found happiness trying out all the crayon varieties in the biggest box of its time, sixty-four colors. Now I had real treasure to mine—gold, silver, and copper.

Invented by cousins Edwin Binney and C. Harold Smith, Crayola brand crayons were the first ones ever made for children. Crayola's first box of eight—black, brown, blue, red, purple, orange, yellow, and green—made its debut in 1903 and sold for a nickel. The word *Crayola* was created by Alice Stead Binney (wife of Edwin Binney), who took the French word for "chalk," *craie*, and *ola* from "oleaginous" (oily) and combined them.

That first chubby set

Similar to the way paint colors look different depending on the subject matter or arrangement, so too have the names of Crayola crayon colors adjusted to reflect

changes in the culture and the world. Prussian blue was changed to Midnight as country names evolved. The Flesh crayon was renamed Peach during the 1960s in recognition that everyone's skin color is not the same.[2]

Try to tap into some sensory memory of playing with color as a child, be it crayons on newsprint, colored chalks on pavement, or the thick tempera from kindergarten. If you missed out on that experience, there's no time like the present.

Part II

. .

THE PRACTICE

5

THE UNPLANNED PAINTING

To empty one's mind of thought and refill the void with oneself is to extend . . .
into a realm not accessible by conventional processes of reason.

—EDWARD HILL[1]

You now have two ways to start any painting: with a dot or a brushstroke. These will be the two basic elements you can return to whenever that next idea isn't forthcoming and you feel stuck. Now that you know how to get started, let's consider the actual process of painting your journal entries without a plan.

In the beginning, the first step must always be to try to clear your head of any preconceived notions or visions. That means starting from a place of *not* knowing what you are going to do, or having no expectation of what will happen.

This is especially important because what we are striving for is a "mistake-free" environment. I've often observed students not yet familiar with this process become excited by the concept of painting "freely," yet when they start off trying to make a particular image—a tree, a flower, a person—they get into trouble. Instead of letting the image unfold as an imaginary creation, they envision what they believe it should look like in their minds and unwittingly limit rather than open up possible outcomes.

This inner picture sets up an unconscious pressure to make the mouth of a figure look a certain way or the facial expression just so. When the image on paper fails to match the vision in your head (and how could it not?), frustration moves right in.

The process you are learning here is about taking baby steps, and the first lessons are designed to be like the games of pretend we played so easily in childhood. If we can think about our painting as if we are *making it up as we go along*, then we free ourselves to discover so much more.

Problems arise because most of us don't handle ambiguity very well. Tolerating the uncertainty of this painting process can be very challenging, if not plain uncomfortable. Life experience has taught us to rely on the security of knowing beforehand what steps we need to take in order to achieve the best outcome. New studies are showing, however, that the more knowledge we acquire, the less likely we are to be open to change or to look outside our own expertise for new solutions. According to a business consultant friend of mine, it's called "the curse of knowledge"[2]; experts can't see past what they think they know to be true. This is the case not only in a work environment, but in other contexts as well. As soon as we say we know, the door gets closed to another way of seeing something, whether it's a new idea or a new image on the page.

It's a curious paradox. The more we know, the less we know.

We can overcome this barrier and address our blind spots by admitting what we don't know and by allowing it to be okay *not* to know. This attitude invites an open-minded approach, which is especially useful when we find we can't control the results. Easier said than done.

Rob came to me during a job transition and was in full search mode for his creative self. It was during our third session that he began painting a face. After adding eyes, a nose, and a smiling mouth, he came to a stop. As it was his first try at a human face, I asked him to suggest other details he could add to flesh it out. He responded easily enough with eyelashes, eyebrows, and ears, but what kept stopping him was that mouth. He didn't like it. The brush had gotten away from him and made it bigger than he wanted—and now it felt too open.

"Why not let it be as big as it wants to be?" I asked. Because, he explained simply enough, it was not how he was feeling at the moment.

Ah! So the real challenge facing Rob in that moment was whether he could let the painting truly be an exploration of possibilities or whether he would be limited by the tyranny of intentions. Better still, which of these options would move the painting forward? We needed to look at what he wanted versus where the brush had led him. Saying this was not a true expression of himself at the moment made him protective of the end result and stopped his process. The alternative—deciding to paint beyond his expectations—would invite the brush to go out of bounds, a more adventurous position. The slip of the brush presented Rob with an opportunity to examine the difference between what his critical mind dictated and what a more creative and playful attitude might offer.

This became a pivotal point for Rob and raised a question he would ask himself again and again: "How do I know whether to follow what I think is me or go where the brush is leading me?" Of course, there is no one answer. Rather, it's a matter of determining which choice moves the creative process forward and which holds it back. In Rob's case, leaving the big smile in place and letting it lead him to the next idea allowed him, finally, to see the face as that of a jester, complete with a hat of bells and musical notes, all of which flowed from that larger-than-life mouth.

Powerful aversions to what we paint and view as mistakes are a common occurrence in the beginning of this work. These are not thoughtful evaluations about what we have done, but rather are knee-jerk reactions. They are "I'm not okay" feelings that we resist and want to make go away but that we really need to question. In fact, these dissatisfactions present the very opportunities we need to begin choosing to do something in a different way. After all, if we are just making this up, then how awful can it be if the mouth or the arm or the nose are too big?

Once while painting in my journal, I was dismayed to find I had given a lady creature one too many legs. In the long-ago past I would have wanted to paint out the extra leg or start over, but this time I resisted the impulse. Instead I added more legs. The shape of these strange legs led me to put toe shoes on the feet. By the time

I'd finished the page, a title had presented itself: *I'm Dancing as Fast as I Can*. It was a testimony to a trying and difficult day. If we let ourselves go with the flow, humor will often save the day.

I'm Dancing as Fast as I Can

This idea of holding fast to what we think we want isn't bad in and of itself. It helps us reach our goals, whether professionally or personally. But it isn't always in the best interest of our creative process. Our definition of who we are may include a sense of our strengths, and if we are honest, our limitations too, but this view can still be too narrow and confining. It can also inhibit our ability to let things just happen on paper. How we see ourselves doesn't usually allow us the room or give us the permission to bring other parts of ourselves into play, be they the trickster, the vamp, or the child. It's normal to strive to dot every i and cross every t as we move forward in our day-to-day lives, but creativity's most talented partner is risk. We need to be able to stretch our abilities to play many parts without judgment.

Let's face it—many actors prefer the "bad guy" roles. And why not? They're so much juicier!

More often than not we are required to work toward specific goals. Bolstered by a work ethic fostered in school and directed by ourselves as we mature, we now live by a perpetual list of "must-dos," crossing off tasks only to repeat them week after week. Necessary, perhaps—but alas, this way of being is often tedious. All the more reason to explore and take advantage of opportunities that lift us out from under the expected. How do we recognize these occasions for reinvention when they present themselves? Do we need to structure them? What would we gain from an unplanned series of moments?

As children we possessed a natural ability to express ourselves freely in the moment. I'm referring specifically to the ages of three and four, when children break into song or create a dance totally of their own making. Like the two little girls painting the "dirty river" in chapter 2, young children will paint an image and expect you to recognize it immediately. There is no stopping to worry if it is done the "right" way or if it makes sense to anyone else.

During family painting classes in my studio, I've had the chance to witness the gap between a parent painting "freely" and that parent's child doing likewise. While Dad or Mom struggles to perfect some ideal on paper, the child invariably has an ever-evolving, transforming story happening with ease. "This is the boat but it's turning into a house and here is the family and my sea now has trees . . ." I always encourage parents to observe and learn from their children's example as they invent with abandon, unrestricted by what is or isn't possible.

Creative acts are all about a willingness to travel into unknown territory. It doesn't matter whether you are a budding Picasso or a beginning student, the process is the same. In order to let something new emerge, our rational brain must step aside and serve the creative process, not be in charge of it. And that's not a supporting role the critical mind likes very much.

The analytical and critical part of our brain—our left brain—is very used to keeping tabs on our behavior and on the rights and wrongs. We are so conditioned

by years of cultural and family mores that tell us things like "Be good," "Don't make a mess," "Anger isn't becoming," "Sex is a taboo subject" that we are unaware of how this automatic censorship is going on all the time and all around us. So it is not surprising that before we can reflect on or even identify an idea or an image on the page, we have rejected it, and with it all its inherent possibilities. What space is left where we can get lost in the mystery of who we are?

Changing ingrained patterns is not an easy undertaking. Patience, practice, and, above all, desire are our greatest assets. In the unplanned painting we work to act before the mind can "block" us. We want to follow our natural instincts as they arise and not be a slave to our inner critic. The exercise at the end of this chapter will help you feel this more playful impulse and move you into a new and exciting place of discovery.

As we make room for our creative voice, we experience small breakthroughs. Every time we are able to stay with a new image—that is, to remain in the process— we stretch our capacity to wait for and respond to whatever will come along on its own. The result is an increase in flexibility and inventiveness that will carry over into all aspects of our lives.

So, how do we actually get this unplanned painting started? As simply as possible.

Exercise Introduction: Doing Nothing

A necessary element of creativity is doing nothing—that is, "nothing" in comparison to our more measurable accomplishments. Meditation offers a model for this kind of concentration. We sit, breathe, and let our mind wander, perhaps bringing it back to a mantra or counting breaths to begin the process anew. The thoughts that invade our meditation are neither right nor wrong, just interruptions that not only help us to clear and refocus but inform us of what kinds of thoughts linger beneath the surface. Physical exercise provides another opportunity for mind wandering, as

long as we are not plugged into some electronic device. Some of my best ideas occur while I'm walking.

In this exercise we take that walk with a line on the paper, not making anything in particular, letting the brush take the lead. Maybe it will evolve into a snaky line or an amorphous shape. Whatever comes through the brush, move with a spirit of ease and lightness. In a very Zen-like manner you want to focus attention on what's happening as it happens. Be in the moment. Stay in the present.

When distracting thoughts interrupt the moment, notice them and set them aside for now. Like the intake of breath in meditation, come back to the line before you. Keep it moving. If, instead of distractions, your mind offers an idea to play with on the page, run with it, continuing to support it with the same attitude of permission and ease.

ON THE RIGHT TRACK

It seems our wandering may be supported by science. At the Mind Research Network in Albuquerque, New Mexico, researchers have been attempting to track what happens inside the brain while engaged in creative activity. University of New Mexico neurology professor Rex Jung used powerful MRI scans to analyze white matter, the deep tissue that coordinates communication between all brain regions. White matter is made up of neuronal tissue containing axons wrapped in myelin sheaths, which act as insulation and move impulses along. In one study Jung asked seventy-two volunteers between the ages of eighteen and twenty-nine to be scanned while engaged in tests that measure creativity—tasks involving divergent thinking and openness to experience.

The scans indicated a correlation between myelin thickness and the two tasks tested.[3] Subjects who scored high in creativity had thinner myelin, signifying a

slower transmission of information, and Jung believes this slower communication might be what allows for more novelty. The studies found that most creative people had lower white matter integrity in a region connecting the prefrontal cortex to a deeper structure called the thalamus—proof, Jung believes, that creativity likes to take a slower, more meandering path than intelligence. Whereas intelligence chooses the straightest path between two points, creativity involves a slowing down of nerve traffic to the brain, taking detours and side roads, in the left frontal cortex (the area of the brain related to emotional and cognitive abilities), which just might be what allows connections to be made between unrelated ideas and thus fosters innovation.[4]

Exercise: Gazing at Clouds

Remember the childhood game of looking at clouds? "That one looks like a rabbit. There's a train . . . No, now it's a dragon." As you wander around the page making marks with your brush, be open to the possibilities. In this painting process, no image is insignificant or mundane. Whatever appears is good enough. That means being open to the simplest and sometimes easiest of subjects—a heart, a balloon, and yes, even a rainbow. We must begin with what we know.

Sample Mantra: "It doesn't have to *be* anything."

1. Load your brush with black paint and take a slow walk around the page.
2. Let your brush twist and turn lazily, alternating between using the tip and the side of the brush.
3. Allow the brush to form shapely blobs from time to time as well as snaky lines. For now, resist making anything recognizable. Just notice whether

you see a suggestion of something familiar as you go along, the way you once did while gazing at clouds. But don't stop to make anything.

Hint: As you are painting, try to keep your eye on the brush and let your eye and brush move together in an unhurried, almost exaggeratedly luxuriant pace. The experience should feel lush and wet, so keep the brush full of dark, inky-black color.

Meander with your brush, varying the pressure.

4. When you are done, gaze at your strokes. Did any of them remind you of something as your brush moved along? Can you still see it?
5. Choose one blob or squiggle and try to flesh it out with as much detail as possible.
6. You may need to cover other black lines that you feel don't belong to this image by layering paint strokes over them. In this process, as I will further explain in the next chapter, an image always takes precedence over

abstract, warm-up lines, unless we want to use them in the formation of this new image.

I think I see a dog–like shape on the bottom left. What could be in his paw?

7. If, on the other hand, you didn't see anything as you went along, that's fine too. Take an area and make up something, like a strange creature or exotic plant. In any of these exercises, you always have the option to simply play with design possibilities.

Hint: When you don't know what to do, the choices are:

- Add color and patterns to shapes.
- Close lines to make new shapes.
- Add more dots and brushstrokes of varying size and color.
- Sometimes just starting to fill in an area with color can trigger an idea or make a form jump out at you in recognition.

*Sometimes as we add color to a shape with nothing
in mind, an image appears on its own.*

Reflecting on Your Work

What was easier in this exercise, wandering with your brush or playing with image possibilities? Don't be concerned if you didn't "see" anything this time. This is where practice and experience come in. It has been a while since our imaginations have been engaged in this way. We need to be patient. Remember, we are inviting the image, not trying to beat it over or out of the head. This is the best point at which to begin letting go of any judgment that makes us feel small about what we make. Allowing, not forcing, is a more organic way to let our images emerge.

*This wandering black line became so many strange
and funny things. I call it* Luscious Lips.

A Greek key pattern

THE MEANDER

Meander is one of my favorite words and very symbolic to this process. Not only does the verb mean "to wander or ramble," but as a noun, it signifies a major motif in Greek art known as the *key* pattern. This geometric meander consists of a continuous line shaped into a repeated motif and named after the Meander River in Turkey, best known for its twists and turns. So common was this key pattern to Greek culture that it was used in architecture, pottery, and coins.

The meander is heavily associated with the labyrinth of Greek myth in which the Minoan goddess Ariadne helps the Athenian hero Theseus find his way out of the maze after battling a creature called the Minotaur. While in ancient times the labyrinth was used to contain the beast as well as illustrate a puzzle (how to find the way out), today "walking the labyrinth" is seeing a revival as a means for meditation and contemplation. So, as you "meander" with your brush, you are embarking on one of the oldest paths toward self-knowledge, and you hold the key.

6

THE LANGUAGE OF IMAGES

Make visible what, without you, might perhaps never have been seen.

—ROBERT BRESSON, FRENCH FILM DIRECTOR[1]

The rich palette lures us to dip the brush in color. Simple lines, dots, and shapes help us to make the first marks upon the paper. As we become more at ease with the tools and develop a playful attitude toward our efforts, the ultimate aim is to see images emerge out of these visual gestures. Finding something out of nothing.

Images are important. They are the nonverbal language of art. They give us a way to tell our stories. A significant aim of this book is to help you learn how to access a library of images you already possess.

"But I can't draw," you say. That may be true or it may be that you can't achieve a realistic likeness. Formal drawing lessons will teach you how to render an object lifelike, but the images we seek are from another source, one that is already inside us, which is one reason we don't have to study any formal graphic techniques in order to make them. These images come through a personal filter. That's what makes the journal such a personal exploration. You could cut out images from magazines, but that would rob you of your chance to discover your own visual language.

Perfection is the very antithesis of what is desired. We are using the painting medium for the very reason that it is hard to control. "Accidents" with the brush are going to provide opportunities for discovery.

For those who fear making mistakes (and who doesn't?) the first step may be to start practicing a more patient and kinder attitude toward the self. Making mistakes is a necessary part of learning, not only in art, but in life. (This can't be emphasized enough.) They actually lead to new possibilities and new perceptions. We want to nurture a more positive attitude toward whatever occurs on the page beyond our control. If we begin to consider mistakes as opportunities for adventure and invention, then we will discover the value of seeing something in a new way.

On the third day of a clay class, Ellen arrived with an idea for her next project. She wanted to do an image from a dream she'd had the night before. This began as a slab of clay formed into a face, followed by hair molded into the forehead and a pair of closed eyes. Soon, however, she became frustrated with the mouth. "He's supposed to look likes he's sleeping, not crying!" she moaned. Her immediate urge was to smudge away the frowning mouth and do it over, unless I could convince her otherwise.

Ellen takes great pleasure in design projects—colors, fabrics, and textures are always carefully selected and combined to create a unique setting. Thus far her clay work had concentrated on pieces that were both decorative and utilitarian—a plate, a ring holder, a bowl. Working the clay into a free-form face was very different from the approaches she had attempted thus far and indicated a new step. I wanted to be respectful of the risk she was taking and support the image trying to appear beneath her fingers.

Ellen and I talked a bit about why it felt so distressing to have a clay face that was crying rather than sleeping. Ellen's reason was that it was not faithful to the dream she was trying to portray—her dream had been happy, not sad. But what if we looked at it another way? While the dream provided the impetus for imagery, it was a story that was already known. Under the movement of her hands, the image had shifted almost on its own, which let the dream story continue. When that happens,

it's like receiving an unexpected gift. Even if we don't like what it looks like, it's too early to judge what the change means. Instead, if we can temper our reaction to it, we can proceed and get the chance to see where it takes us. Maybe the frown was thoughtful, not sad. Maybe the tears were about a memory. We just don't know yet.

The moment the brush goes its own way, a more intuitive part of ourselves gets to speak. Often, when I begin talking about image making, some student will challenge me with the question, "What's wrong with working in the abstract? I learn a lot about myself working abstractly." There is no inherent right or wrong whether choosing to make an abstract mark or to make an image. Remember we began with abstract shapes and lines, and it's a part of the process we can always return to when we're stuck. However, in this work there is a *distinction* to be made—a preference for the image over total abstraction—and here's why . . .

The best way to answer the student's question is with one of my own: "What is the intention?" Consider, "Am I opting for abstract because I feel the real objects I make aren't good enough? Do I stay with abstract painting because that is *what I do*? It's more *me*?" These statements usually translate into "I know my process. I don't want to be told what to do. I don't want to be like everybody else." I can understand this thinking, because when I began exploring this process, I was an Artist (capital *A*, please) who had a boatload of "shoulds" left over from my formal training—the picture should be composed, color balanced, accented, blah, blah, blah.

We will talk more about loosening up the viselike grip we may have on what we think defines us in the next chapter. For now, let's just say that I believe the act of making an image, as opposed to leaving an undeveloped blob of paint on the page, asks us to make a commitment. It requires a leap of faith and trust of that inner voice. The risk might best be understood as akin to being asked to voice an opinion or answer a question out loud. Right or wrong, there it is and I stand behind it. It may not be the best I can make, but is in this moment. Am I willing to hear another point of view or reconsider my position? Yes, certainly. But first, I must open my mouth.

I must try.

When I give lessons on the art of other cultures in public schools, I find students often unwilling to let themselves guess at the answers in our discussions. My questions are usually open-ended, offering many choices. Still I watch a child's eagerness to answer turn in a split second to a face full of doubt, a child shaking his head frantically at me as he backs out of speaking up. This self-censoring is like the nipping of a bud about to flower. We do the same thing any time we stop the brush from exploring some new shape. We hesitate because we're unsure of what's coming.

Since we may not yet realize the extent to which our mind filters out thoughts and images, an important first step is to acknowledge that this is indeed happening. Understanding begins with recognition. We can't interrupt the pattern until we begin to notice when the censorship occurs. Just as we would never hold back the words a child needs to learn in order to express himself, we wouldn't want to hold back the images we need to express ourselves visually.

Working slowly and in a very focused way, moment to moment, is our means to this end. Staying with the brush's movement to the exclusion of everything else quiets the managing, verbal brain. This approach makes space for something else to come along. Moving with care and intent allows time for possibilities to arise, for some idea to bubble up on its own. Painting too fast or wildly results in rushing past these windows of opportunity.

We want to stay connected to the brush and paper. As you move your brush, tune in to the subtleties of each twist and turn, continuously looking, looking. This is the meditation, the focus. When the moment comes and an image begins to suggest itself, stay with it until it's completed. We often think we need to hurry to fill in the surrounding areas, providing context. Resist that pull, as it's a distraction. Only art school instructs painters to work the whole canvas. That technique only takes us away from the discovery at hand and the focus needed to flesh out what comes to us. If you fill every area because of some rule, how can something new emerge? Gradually you will begin to see and trust that every part of your picture gets born in its own time.

If, for instance, a line begins to suggest the snout of an animal, don't worry about

what animal it is. Whether it resembles a pig or an elephant, try not to "manage" the creation by deciding how big or little it should be or if it should be walking or dancing a jig. In the initial stages it is much more important to let the movement of the brush make these decisions, by accident, if you will. Try to make a perfect pig and you will be unhappy. If the brush gets away from you and one leg is longer than the other, let it be. Don't try to fix it. The ability to accept how something is executed, no matter how simple, immature, foolish, silly (or anything else the critical brain insists it is) is key to freedom.

Many creative discoveries come out of something accidental. If it is helpful, think of the signature qualities revealed in the lines painted by Matisse or Picasso. They are distinctive to the artist and occur in the exaggeration of the brushstroke. An emotional response is evoked in the viewer by that exaggeration. Because we learn to write with pen on paper, we have a signature line too even if we aren't artists. So let the leg be longer or the eye droop lower. It will be just the right expression for this pig. Move on to the next feature. Keep the momentum going. See this as a stream of consciousness. Let your painting flow like a dream, and play.

OUR AMAZING BRAIN

At age thirty-seven, Jill Bolte Taylor had the terrifying and remarkable experience of a massive brain hemorrhage. I say "remarkable" because as a brain scientist she was able to realize what was happening and made a conscious choice to also be an observer of her own stroke in order to pass on whatever insights she gained to others. Charting the course over the eight years it took her to recover all physical and mental processes only deepened her awe of the resiliency of the human brain.

Taylor's loss of function on the left side of her brain gave her the opportunity to experience firsthand the differences and coordination that exist between the left and right hemispheres.

The right hemisphere, designed to remember things as they relate to one another, gives us our ability to recall isolated moments with such clarity and accuracy. Where were you when _____ happened? To the right brain there is no time except the present moment; each moment is alive with sensation, as the right brain works in images, like a camera. It also sees the big picture, how everything is related, and how we all join together to make up the whole. Because the right hemisphere is free to think intuitively rather than by rules and regulations (as is true with the left), it allows us to make connections between seemingly unrelated things and find new solutions that the left and logical hemisphere simply can't see.

The left hemisphere, however, takes each of these moments created by the right and puts them together in a timely sequence. The comparisons it makes between each of these moments structure time into past, present, and future. We are then able to know the order in which things happen and plan accordingly. ("Before I heat the soup, first I must open the can.")

The left brain thrives on details and organization. It is the language center and uses words to define and break up the big picture of the right into manageable pieces by categorizing the data it finds there. This has great meaning for our painting purposes. The left hemisphere takes the facts and details it collects and brings them into context, into story.[2]

Exercise Introduction: Inviting the Image

According to neuroanatomist and author Jill Bolte Taylor, our right brain thinks in pictures and is always looking to see how everything is fitting together. The left brain breaks our experiences down into details, giving sequence to our thoughts in order to create story. Pictures and story—we already have the greatest tool, our

brain, working on our behalf. All we need to do is tap into something we already possess.

Exercise 1: The Painted Word

This time, instead of doodling your way to an image, we will start with one. Choose a word that suggests a feeling, sensation, or mood that you can think of symbols for. An example could be sadness, which might bring to mind tears, clouds, a frowning face, a broken heart, or the color blue.

Use one of these suggestions or come up with a word of your own:

Love	Tenderness	Fear	Anger	Hate
Comfort	Pain	Serenity	Joy	Grief/Loss
Excitement	Peaceful	Mysterious	Horror	Playfulness
Loneliness	Graceful	Moistness	Electric	Tempestuous

Sample Mantra: "Lollipop trees rule!"

1. Start with one image and paint it in the simplest way. While some feeling or state may suggest a popular symbol—for example, the peace sign—feel free to use ideas from your own experience or philosophy. The idea of "peace" for me is sometimes simply a cup of herbal tea!
2. Add whatever details and colors you can think of. If it's a smiley face for happiness, add hair, ears, a hat. Each additional image can go anywhere on the page. They do not have to "connect" with one another.

Hint: Be aware that other feelings may come up while working on this. Try to include images that symbolize these changes as well, or at least notice the shift.

3. When you don't know what to do, weave some dots or brushstrokes in between your images until another idea comes along. If nothing else evolves, stop.

"Peace" as candles, a baby, my bed, and a cup of tea

Hint: Remember, nothing is too mundane. We want to make use of simple and even "trite" symbols. We're using them in service of learning to paint images. We must start with what we know, be it ever so humble or humbling!

Ask Yourself

• Did the feeling you chose change at any time while you were painting?
• What other feeling arose?

- Did you consider giving that feeling an image or symbol in the painting?
- Can you take that feeling and give it an image somewhere on the page right now?
- What image or color would you associate with it?

Reflecting on Your Work

This is a particularly helpful beginning exercise because it invites the use of concrete everyday symbols we already know, and provides an opportunity to play and make up personal ones. The surprise element for students is just how often the task generates other feelings beyond the one selected. For instance, frustration might arise over your perceived lack of ability, or instead of happiness, sadness could be triggered by a color or symbol. This is not a drawback—quite the opposite. Engaging and noticing our feelings and giving them concrete images on the page is the very way to learn about some of our most common blocks.

Exercise 2: Organic Painting/Branching Out

While practicing with the brush, we have been filling the pages, loosening up. In this exercise we will invite images to unfold slowly in a more organic way. Although we have used lines already to put something on the page, these lines can unfold in another way, like those found in nature. The bean plant cracks the earth's surface with a single shoot, dividing itself over and over into tiny branches, while the roots are busy below doing the very same thing. Like the plant, we invite more possibilities when images flow from one to another.

Sample Mantra: "Everything in its own time."

1. Choose one of the following colors to use for this exercise: blue, red, brown, green, or black.
2. Create a curvy or straight line that goes from one corner of your paper to the opposite side.
3. Keep dipping your brush back into the pigment as you go along to ensure a deep, rich color. Now add a total of 5 new lines coming out of the first. They should emerge from both sides of the original line and be long, using the space available.
4. Add 3 to 4 new lines to the last set. The lines are now of course getting shorter each time.
5. Add 2 to 3 lines to each of these . . .
6. Add 2 more to each. How small can you go?

A curvy, branching line in black

What do the lines remind you of? Whether you see arteries, veins, the nervous system, tree branches, lightning bolts, roads, or rivers, complete the painting with whatever details the lines suggest to you. Make a game of it. Add leaves or cells, cars or street signs, boats or fish. Do it in the simplest way. Don't worry about perspective, size, or proportion. None of those things matter; only making the next mark matters. If no images come, then complete the painting with more color, lines, shapes, and patterns.

Hint: It is always more important to get into painting rather than to spend too much time waiting for an idea or image. Part of this discipline is to stretch the weak muscles of the imagination. You may unconsciously be

This same exercise with two branching lines, blue and green

waiting for the right or best idea, which won't get the process going. You can *always* begin with dots, lines, and patterns.

Reflecting on Your Work

While I always worry that students might feel the beginning of this exercise is too structured, it remains a perfect paradigm for the way living things germinate, seed to shoot, shoot to trunk, trunk to branch. So too, in our painting work, one idea can grow out of another. While the first few exercises covered the whole page quickly, once you are comfortable with this painting process, I will encourage you to try also working one image or shape at a time to completion, letting one thing inform what happens next on the page rather than filling it up too quickly.

7

OOPS, OUCH, AND AHA!

Be gentle with yourself; show yourself the same kindness and patience you might show a young child—the child you once were. . . . If you will not be your own unconditional friend, who will be?

—DAN MILLMAN[1]

One of the most elusive concepts of the creative process is the idea of caring about what you are doing without becoming too careful. This concept will need attention and practice until it becomes natural for you. I see this experience as similar to that of the gymnast who searches for the exact distribution of weight needed to cross the balance beam. It takes hours of practice, repetition, and feeling things out to make it happen. For the singer, it is the paradox of remaining focused on the music without letting the voice become tense. In my classical vocal studies, I found the multitasking required—concentration on pitch, learning the notes, enunciation, breath, and often a foreign language to boot—made it incredibly challenging to sing a relaxed interpretation of the music.

To be careful implies the need to be wary, to be on the lookout for danger. Being careful means being protective of oneself, to avoid becoming too vulnerable, lest we slip and get into trouble or make a "mistake." The word *careful* may be a code word

for *stop*. For example, I was walking around class looking for signs of creative blocks when I noticed a student painting the same lines over and over as if unsure of what to do next. She admitted she liked what she'd made so far and was afraid of ruining it. She said it was important that anything she added now be just right, so she was waiting for inspiration. But this is a myth. Waiting for the "right" idea usually leads to idle time during which creative energy withers away. She was blocked by overprotecting what she'd done so far. I asked the student to name some things she could add but didn't necessarily have to. She didn't want to try and was sure this was *not* the way to find the next idea, but finally she named a candle, cupcakes, and then, after a moment, out popped the word *chickens!* It was so out of the blue and surprising that she started laughing. We both laughed and in that moment I knew she'd found her idea.

Caring is all about being vulnerable, whether we're engaged in making love or making sculpture. Caring is also about being kind to yourself while you are in this vulnerable state. You need to treat yourself and the pictures that you create with respect and humility and accept what comes out of you. You are putting a lot of effort into making space for this "new" something to emerge. You want to be as encouraging of this beginning as you would be of a child learning to ride a bicycle. We don't want to frighten off this budding potential with self-recriminations like "Not good enough!"

When we react to these first steps into the unknown with distrust or even contempt, we need to understand this as the analytic mind trying to run the show. This part of the brain is not used to stepping aside and letting something new that it can't control have space. As we begin to recognize and become curious about a new voice instead of being reactive to it, we will begin to trust whatever forms emerge.

Often, when we find we don't like what we have done, there is a great urge to make it go away, to cover it up. This moment of venting fear or anger by destroying the work takes us away from ourselves and away from the process. It is a very pivotal point. We have a choice. We can either let the destructive energy take over and run

the show or we can keep the energy focused in a way that works through the feeling. By translating this energy into a symbol, we stay in the creative process.

My student Doris ran headlong into her critic during her very first class.

Impatience and disgust appeared while she was attempting to portray a human figure. Painting images of people is one of the most intimidating things for students. Nearly everyone gets distracted by whether or not her person looks "right," meaning anatomically accurate. But anatomical accuracy is not what we're striving for here. Doris didn't see that she was already in a position of strength; she had taken on the risk of creating a person in the very first class. Because of that, she was presented with the opportunity to "speak" to her inner judge who deemed her painting so unworthy.

Together we tuned in to this critical voice to ask what it really wanted and found its desire to smash everything in the painting. I helped her to brainstorm images that she could paint to express those feelings. Instead of destroying her human figure, she painted bombs and rockets exploding overhead. When next I looked over her shoulder, she was adding a colorful parachute floating high and away over the bursting flames. It was then that she was able to go back and finish her person without second-guessing her ability.

Intuition will never call for you to destroy what it has given you. The temptation to fling paint wildly in strokes that cover up images may feel good in the moment, but ultimately it will backfire by killing off your initial and innocent enthusiasm. Freedom does not equal carelessness. Freedom, in its truest sense in the creative process, is the development of an attitude that goes beyond "mistakes" and "no mistakes." I hear the voice of Janis Joplin, "Freedom's just another word for nothing left to lose." When we can acknowledge that we have nothing to gain or lose, then we are really free to create without worry.

When we work as if we care about what we are doing, we bring a certain kind of focus that makes room for a deep connectedness to the movement of brush and paint. We allow ourselves to be in the experience instead of standing outside

listening to the critical voice. Our caring then is not about being overly cautious and making things perfect. Real care comes in the doing. The doing itself is the purpose and is a result of the focus we give moment to moment. That is why the brushes we use are so well suited to this work. Their responsiveness to our touch keeps us connected to the paper and the moment.

This kind of balanced focus is not particularly easy to achieve, but it can result in valuable rewards. As we hit waves of feelings in response to images or colors made on the page, we always endeavor to keep the process going. The arousal of any feeling—shame, anger, fear, sadness, as well as great joy and excitement—may create a block because we are getting close to a breakthrough, an opening to a new idea. We may not be used to tolerating such intensity of feeling and we may back away, or respond by letting the emotion take over and direct the process by x-ing out everything we have done.

With practice, however, we can opt for a more constructive way out of the struggle, and that is to go through it with patience, kindness, and an image to help us reevaluate what the feeling is really telling us about our process. How can we hear and respond to these messages in a new way?

I am reminded of a lecture I attended on the psychology of food and the eating habits that surround it. Of all the speaker's points, one simple message resonated with me—the tools to change are within us. Eating well is about listening to the messages of the body and learning to discriminate between the fearful and often critical voice and the authentic voice. The first says, "I'm not happy about myself; give me some chocolate to dull the pain." The second says, "I'm really not hungry; I'm anxious. I wonder what that's about."

In our hurry-up, eat-it-on-the-run culture, we've learned to override our body's natural rhythms and cravings. We put up with fashionable shoes that scrunch our toes or sit in cubicles too small to stretch our legs. About some of this we have no choice, which makes it all the more vital to make room for the body where and when we can and to hear what information it has to tell about how we are feeling.

Jeff had been painting for about thirty minutes when he began to get a headache.

I had noticed him rubbing his neck and came over to check out what was happening. He'd been working on a huge, colorful, ducklike creature when his energy dropped and he didn't know what to do next. Now he felt tired and his head hurt. We played around with some possible ways to keep going. What might be on top of the creature or behind it? Was the duck wearing anything? But nothing seemed to click. I had him drop his arms as I guided him through a body scan to pick up on any hidden sensations. Rather than finding the pain in his head, he found a tightness in his neck. "What kind of tightness?" I asked. "Is it imposed from the outside or is it something inside the neck?"

When he was finally able to articulate an image for the sensation (two hands squeezing), I encouraged him to put it somewhere in the painting. That's when he saw that his picture had already provided a neck (the duck's), and that's exactly where he wrapped the two hands. I came back to him as he was finishing, and he said that as he was painting the fingers, he'd suddenly remembered what had happened just before the block occurred. He'd had an idea to put the figure of a woman riding on the duck's back but then decided it was too hard to do. That's when he'd hit a wall.

The block in Jeff's body was perhaps a response to the blocked image. Was he willing to try to make her now in the simplest way possible, maybe just a stick figure? "Yes." His neck was considerably more relaxed after that.

THINKING OUT LOUD

One of the techniques I use to guide students through a block is to ask them to name two or three things they could easily add to the picture. A lot of times they will nod their heads as they think of ideas but don't tell me what they are.

It isn't that I have to know everything; rather, the possibilities need to be said aloud. Keeping the thoughts inside the head does not engage the imagining brain in the same way as when we put the words out there.

I believe this is like turning a paint blob into a definite image. As long as the stroke remains nebulous, there is only so much we can interact with it. Once we make it into something, we can have a reaction to it and then go deeper. So it is with ideas—once we say our ideas out loud, they have substance. The words themselves become bridges to the next thought and the one after that.

Just as important, once we say something out loud, it can't be taken back. That may be why my invitations to play what-if games are often met with resistance. I think it stems from shyness or fear that what's said off the cuff could be a mistake or sound foolish, bad, ugly, mean—any number of unwanted possibilities.

My take on this is that we expend a lot of energy in the everyday trying to say the right thing, on being politic and trying to please and take care of others. There needs to be a safe space to lift the filter and let the imagination go, even if the results aren't out of Miss Manners's playbook.

The truth is, letting yourself spout whatever comes to mind is just playful and funny, not usually taboo. There might be more we can do with an image and we can spark those ideas by asking certain questions, such as:

What could it be holding?

What could be standing behind it?

If it had a hole in the top of its head, what could we see inside, coming out, or going in?

I want students to just let their minds go with as little monitoring as possible. The answers don't have to make sense, and it also doesn't matter whether they are simple or extreme. As words first spill out, they may feel too prescribed or forced, but then something else may emerge. Suddenly an idea you hadn't any clue existed pops up, and it has energy or it's very funny or you feel excited about it.

And that's the thing you paint.

This takes practice. Just as there is training involved for the eye to see images in a blob, brainstorming possible ideas out loud takes discipline as well.

Exercise Introduction:
The Gift of the Block

In the painting journal everything is fair game. That means anything that helps us come up with another image is to be exploited. I am reminded of an aikido master I once observed at a corporate symposium on innovation where I was giving a painting workshop. He was demonstrating how to use your body when encountering an attacker, in particular someone coming at you. He explained that to try to meet the force with equal force increased the level of risk, especially if the attacker was bigger. But when the master did the same demonstration and let his body go limp, or moved as if to help his attacker, it threw the other guy off balance.

In this way, instead of fighting with our blocks—that is, trying to "override" them with mental determination—we can let them guide us to an image that will supply a constructive discharge and perhaps an insight into their being.

Exercise 1: Paint Your Critic

Try to recall some of the inner commentary that may have interrupted your process while painting or perhaps in some other venture. Was there one disapproving "voice" that made you doubt your ability or your imagination? Was there a critic who held you up to some impossible standard, saying, don't pursue anything you're not going to be the best at? Critics come in all shapes and guises. Sometimes they echo a real person in our past, like a teacher or relative. Other times they might sound like some of the brutes hanging out in the alien bar in *Star Wars*. One sure way to defuse the critic's power is to turn it into a caricature of itself. Do this exercise over and over as needed, and you'll discover no two critics are ever exactly alike. We've got plenty of variety!

Sample Mantra: "It's only paint and paper!"

1. You might already have some idea of what your critic looks like, but as with previous explorations, remain open to whatever changes or detours need to happen along the way.
2. You don't have to know all the details when you start.
3. Start with a blob of any color. Let the blob define the shape of the head or the body.
4. Be as daring as you can be and make the baddest dude there is.

Witchy School Teacher. *The first critic I ever painted was this prim and disapproving old lady.*

Hint: Tap into your sense of humor. As Clint Eastwood said while reflecting on his Oscar for *Unforgiven*, "Take your work seriously but not yourself and you'll do all right."

Ask Yourself

What kind of voice does your critic have? Is it cranky and dry, or loud and
powerful?
Is it mean-spirited and stingy like a character straight out of Charles
Dickens?
A schoolyard bully?
Spoiling like an envious, wicked queen?
Bloodsucking like a vampire?

Green schoolyard bully. *Later critics were much more visceral.*
As I added the choo-choo train above, I heard the words to a childhood
record fill my head. "Casey Jones, mounted to the cabin, Casey Jones
with his orders in his hand. . . ." I laughed and suddenly felt better.

OOPS, OUCH, AND AHA!

Blow-you-away angry like some kind of ogre?

Man-eating like a giant?

Fire-breathing like a dragon?

Reflecting on Your Work

You will reach a point in your work when you may not have to designate a specific page for the critic as these monsters and bullies emerge in a more organic way in your process. If you can give these demons a face as each one arises, you'll discharge their destructive energy before they have a chance to do damage—the bomb gets defused before it can go off.

A GAMMA SPIKE OF INSIGHT

Like the "chickens!" example cited earlier, some of our best ideas come suddenly and seem unrelated to the immediate problem at hand. That aha moment has been the subject of new scientific studies on the phenomenon of insight, in which the brain not only solves a problem, but can reinterpret a situation, explain a joke, or even make sense of a blurry picture.

According to psychologists John Kounios of Drexel University and Mark Jung-Beeman of Northwestern University, solving problems by insight differs greatly from using an analytic process. First, insight is characterized by the solver coming to an impasse because he is no longer able to move forward on the solution. Then when the solution does come, the solver can't explain how he got to it. The third aspect has to do with how the solver experiences the suddenness of the answer (the eureka moment) and how he knows, without being able to explain it, that the answer is correct. To better clarify these characteristics, Kounios and Jung-Beeman decided to use simple word puzzles in two experiments to examine

and compare brain activity as subjects used insight or analytic processing to come up with the solutions.[2]

Both experiments gave the study subjects a series of three-word sets and asked them to come up with a fourth word that, when combined with the other three, formed new compound words. The report gave the following example of words—*crab*, *pine*, and *sauce*. Give up? (I didn't get it.) The answer is *apple*: *crabapple*, *pineapple*, and *applesauce*. Another piece of the experiment asked for subjects to note whether the answers they gave came to them in a flash (insight) or whether they had to work to find a solution.

The first experiment, with eighteen young people between the ages of eighteen and twenty-nine, used functional magnetic resonance imaging (fMRI) to record changes in neural activity. These scans revealed increased activity in the right hemisphere when insight was used to solve the problems.

Using the same word puzzles, but with a new group of nineteen solvers, the second experiment revealed something remarkable. This time recording the brain activity using electroencephalographs (EEGs), Kounios and Jung-Beeman were able to see that when a puzzle was solved with insight, a burst of high-frequency activity occurred in that same right temporal lobe just as the aha moment occurred—a very distinct difference from the brain activity of those using the analytic process. That gamma activity indicates a binding together of neurons as isolated brain cells connect into a new neural network. Kounios and Jung-Beeman's study showed the gamma-band insight effect also reflects the sudden move of the newly found solution from unconscious to conscious state.

Ever shut your eyes to think better? Kounios and Jung-Beeman noted that just before this burst of gamma activity, there appeared a slower alpha band of activity.[3] This alpha band is the brain's rhythm for indicating an idling state or inhibition of certain brain areas, a way of reducing incoming and distracting visual information while the brain searches for a solution. This lines up beautifully with our findings about the brain meandering, slowing down, and turning off areas to do with inhibition during improvisation.

OOPS, OUCH, AND AHA!

While all problem solving depends on a shared cortical network, the sudden flash of insight allows us to make connections and find solutions that we previously couldn't see. The remarkable part is that these connections are made between already existing bits of knowledge—the bits are just being put together in a new way.

Exercise 2: Body Talk

Creative blocks can sneak up on us. They may start with a feeling we barely even notice at first. We may try to ignore the feeling, brush it away, or even actively will it away. That's when we get the full-blown headache, the backache, or the sudden urge to lie down. But there are other times too when we just get stuck and we're not aware the body is trying to tell us something. At one point in my own discovery process, I found I was often holding my breath while painting. Was it any wonder my arm or neck would be stiff and tired by the end of my day?

Scan your body using the directions below and check for any physical sensations. This works even when you don't feel blocked.

Sample Mantra: "Just breathe."

1. In a standing position with your arms loose at your sides, scan your body from head to toe for any sensation. Start with the head, moving slowly down the neck, shoulders, and chest. Move front to back and back to front, making sure to include the midriff, abdomen, hips, and buttocks. Proceed slowly. Sometimes we don't realize we are tensing a shoulder or are holding our breath.

2. When you have completely checked out your body, ask yourself where there was a sensation. Try to describe it out loud. Is it hot and burning, or more of a chill? Is there a knot somewhere, heavy and tight, or a tingling or sharp sensation?

3. Get specific. Is it as hot as burning coal or more like a glass of warmed milk? Is the knot made of bulky sailor's rope or tightly wound silk?

4. Paint an image of your sensation. If your sensation is pleasant instead of tense, you can still play. Is it soft like flower petals or limp like a hammock?

5. Can you add a body outline? If you are willing, paint the part of the body necessary for the image. For example, an image of heartburn could be

The Ugly Ducking. *The more I gave the yellow blob human features, the more pain I felt. After a quick body scan I knew just where to put my tortured heart and green bile.*

OOPS, OUCH, AND AHA!

the shape of a heart (human or symbolic) outlined around a flame. Or make the body first. Like all these exercises, there is no one way to do it.

Hint: Painting something simple, like a dot, is a way of keeping your motor in "idle." Think of it as jogging in place while waiting for the light to change. The body/mind muscles stay warm and loose while we wait for the green light or the next aha!

Ask Yourself

Once you have transformed the sensation into an image on the page, how can you continue the painting? Ask: What is under it? Over it? Is there more of it?

Reflecting on Your Work

I have seen this body-scan exercise prove itself again and again. The ability of the body-mind relationship to heal is discussed by many medical gurus. (Doctors Andrew Weil and Bernie Siegel come to mind.) Giving the sensation an image eases the somatic symptom. Another student was feeling stuck when, at my prompting, she checked out her body and identified a sensation that she described as heavy, as if she were being weighed down by huge boulders. After painting about a dozen such rocks, she began to elaborate on them, painting moss and smaller stones until the image turned into a farmyard wall, which then led her to paint a country lane. Because she was able to get lost in the process of painting, her energy returned and her heaviness left her. The deeper into detail you can take a painting, the better the release. With practice, you will be able to incorporate this technique of painting the block as it arises during any painting session.

8

LETTING GO

When I let go of what I am, I become what I might be.

—Lao-tzu, Chinese Taoist Philosopher[1]

As students become more trusting of the method of painting without a plan, I begin to hear a repeated delight: "Class over? Where did the time go?" But I know this is not everyone's initial experience. For some, the two-hour class can drag on at first, as they battle fears and resistance over making marks upon blank paper. With time and practice, however, they learn how to get lost in the flow of the creative process.

The issue of control is the biggest barrier to entering this kind of flow. Most interruptions to the creative process happen because we tend to cling, understandably, to already-formed perceptions of who we are as soon as we approach a state of uncertainty or risk, leading to a continuous tug-of-war between how we see ourselves and how we respond to what we've just made. But statements like "This is who I am" or "This is *not* who I am" lie in direct opposition to an open stance toward our own work. These definitions can block us from discovering what we may not know about ourselves or what about us has changed. The inner dialogue might sound like this: "This isn't what I meant to paint. It's not how I saw it in my mind.

I came to class happy, wanting to paint something pretty, and now, instead, everything I make looks drearier and drearier."

It can be hard for all of us to let go of this way of thinking, even for those who are accustomed to getting lost in their own creative flow in other aspects of their lives. My student Emily, for example, was a very creative person. Singer, artist, and mother of two, she created things that were unique and rich with imagination, no matter what she turned her hand to. She took my course simply because she didn't have enough time to paint and was interested in the process I taught. It sounded like fun to her. When she finally became blocked during her third painting, I asked the usual round of questions: "What could be over in this corner or down in the water you have just painted? Could something be coming up?"

Without an ounce of hesitation, Emily replied, "No, I'm not going there. I want to paint happy pictures." And she did. Butterflies, rabbits, and children's faces—always stopping at the same point because she liked the picture the way it was and didn't want to ruin it. I take my students as far as I can, but in the end, they each choose just how far that will be. During one class, Emily began painting a woman dancing the hula. It was a sunny and colorful image, and she was obviously having fun until she painted one of the dancer's arms. She hated the way it turned out. She had done it in a bold stroke, and it had energy, so I encouraged her to let it be. In redoing it she might have lost the spontaneity and gesture of the moment, the innocence of the image. Still, she insisted on painting it out and doing a whole new arm. "I didn't like it and now I do," she told me triumphantly when she'd finished.

It is at these moments of strong dissatisfaction that we need to be curious about the depth of our reactions and make an effort to interrupt the negative, knee-jerk thoughts that stop us from accepting what we've done. This is the time for "talking back" to that frustration with new words, whether they be a mantra—"It's only paint and paper!"—or some other gentle and supportive phrase.

What is it that we are afraid of? What is it that we think we will lose if we give up control of the image before us and let something else emerge? What if we accept the images as they are? Comments such as "dreary" or "not good enough" are sub-

jective and critical. Should we trust the voice that tells us this is so? Would we hand over authority so easily if a stranger came to us with the same pronouncements?

The first piece of advice that I give students is to be curious about those voices that speak inside us as "I" or "me." ("I want. I need.") These pose as authorities or gatekeepers. They are often the thinkers, planners, and doubters inside us, not the explorers or the challengers. They like to control whatever is off the well-beaten path. These voices most likely played a role during challenging moments in our lives and offered a certain amount of protection, but now, in this moment of striving to tread new ground, we need to ask ourselves, "Is our guard needed here, in this space and in this activity?"

Basically we already know what the rational brain wants, which color it prefers, what beautiful image it wants our hand to paint today. Self-discovery calls for giving voice to what the blocked part of us wants and doesn't get to express. If we can surrender our hold of the "rock" of how we perceive ourselves, and let ourselves float, we can experience a timeless, effortless dimension where we get lost in the process and hardly even notice the minutes, maybe even hours, ticking by.

Swimming is a wonderful metaphor for this approach to painting. The act of surrender and relaxed control in the water affords us the ability to stay afloat. Beginners who thrash around in a panic to avoid going under actually put themselves in greater danger of drowning. They must first learn to let go, stay calm and focused, and work with the water before they can swim.

Painting is also about focus, the kind that stays moment to moment, zooming in on the motion of the brush as it moves across the page, which allows us to let go of time, space, and effort. It's what Buddhists call *samadhi*, a state of concentration in which the world falls away and we forget about having to be mindful of our p's and q's. We just *are*. There's no attention paid to other activity in the room, noise on the street, or fluctuations in temperature. We are at one with the paper, and the images, shapes, and colors just flow.

What interrupts this flow is but one of many paradoxes inherent in the creative process. Students demand so much of themselves while expecting so little in return.

I see this in the level of perfection students go after. They expect to have each solution immediately at hand, to always be able to make something different, perfect, and new and to produce only what they deem to be meaningful. What a burden.

On the other hand, they give themselves very little support to meet these expectations. There is scant room for the trial and error necessary to let something happen, and little time to lose their way. In this process, every painted dot is but a stepping stone toward the next one. There is no need to count how many dots have to be made nor how long it takes to get to the breakthrough *aha*—the next germ of inspiration.

Put aside past lessons that dictate, "When the going gets tough, the tough get going," or "Winning isn't everything; it's the only thing." The first statement, attributed to both patriarch Joseph P. Kennedy and to football coach Knute Rockne, is taken to mean that in a bad situation, it's the strong who work harder. The second, from coach Vince Lombardi, implies that we should do whatever it takes to win, no matter the cost or effort.

While working or pressing harder may be productive in politics or sports, intensifying the effort can turn back on itself, leaving us even more frustrated and angry, and less willing to try anew in the imaginative process (and in most learning situations). Down goes self-esteem. The harder we press, the more elusive the gratification.

Sometimes it takes more strength and effort to *stop* trying so hard than it does to press on. I saw this with my student Bonnie, who was a teacher helping young people with writing and creative projects, all the while dying to be doing something imaginative and fanciful herself. She'd bought the paints and the paper ages ago, but on the shelf they sat. What was stopping her? She was now ready to learn. Her first few pages flowed with ease, colors and shapes fairly flying from brush to paper. At about her fourth painting, something inside her hit the wall. A strange, froglike creature had emerged, and something about it would not be tamed. The more she tried to make it cute and clarify its arms and legs, the more confused the figure became, as though it refused to let itself be defined in any way. The more she tried to prettify it, the more "ugly" (her word) it became. After several conversa-

tions, she was finally able to just let it be—unresolved, she felt, but honest in outcome. It was what it was, and that had to be all right.

To try to meet expectations without patience or without a willingness to let our fingers get a little dirty and let the brush muss around a bit is a useless pursuit. Once free of the pressure of "success," we will be surprised just how capable, inventive, and alive we truly are.

A clear example of this is the weekly "I can't make that" responses I hear students form about ideas that have bubbled up in their minds. Instead of taking the risk, students opt to paint something else. Whatever image gets put in place of the original idea won't have the same energy and may even lead to a block. That "I'm empty" feeling is a false message. You had the answer but dropped your own ball. As discussed in chapter 6, if you give yourself the encouragement and kindness to let the brush paint the image in its own way, the best way you can in this moment, you give yourself the greatest gift—the belief that what's inside you is enough. You don't have to look elsewhere or work harder for an answer; it's already there. Now stand behind it.

Ask yourself, "What would I say to a child who puts down his brush and says, 'I can't. I don't know how'?" Be the same understanding and compassionate parent to the timid or frustrated child in you. Maybe we need to put a different spin on the "try harder" ideology and what it means to be strong and heroic. Think of Rosey Grier, that big NFL-er who liked to crochet and who sang, "It's All Right to Cry," on the recording *Free to Be . . . You and Me.*

In the business world, executives go mountain climbing or deep-sea diving in order to learn how to rely on themselves and trust one another. Try putting a paintbrush in their hands, as I have, and you will discover another kind of courage. Nothing levels the expertise of a group like being thrust into a foreign situation and not having all the answers. That's when people find there's "muscle" here too, and it involves being oneself without the mantle of job, family, or community. It is quite a freeing experience.

Thirty-five corporate consultants and trainers were sitting at round tables set

with paints and brushes and a large circle of canvas to work on. This too was painting without a plan, only as a group activity. Each person was instructed to improvise his or her own shape, line, or image with the brush and then turn the "wheel" to the person sitting on the left. Each successive turn invited another detail, line, or shape to be added to what was already on the canvas, culminating in an overall design. The guidelines given were designed to create a safe environment for exploration— nothing was a mistake. They were simply asked to add paint without covering up another's mark, refrain from splattering or dripping paint, limit conversation for focus and concentration, and at my instruction, trade paint colors.

The outcomes along the way were as varied as the group. After I gave instructions to make imaginary trees, John, an executive at a high-end finance company, found himself reciting a poem aloud as he painted, much to his own surprise and the delight of those in his group. The words, a parody of Joyce Kilmer's well-known "Trees," pitted a poor defenseless tree against the next speeding car and its youthful driver. The table broke out in laughter, any tension about the exercise falling away. Here was a side to John that the others had never seen before in all the meetings they'd had together.

Susan, a business owner, answered the "tree" suggestion by painting a colorful chart of her own family tree, making a visual pun. Most people felt inspired by the support everyone was giving one another, but at the other end of the spectrum was Marian, who when I proposed guidelines for building trust, heard them as "rules" and immediately decided she would not be held by them. She felt that in order to express her individuality, she had to do something different from the others in her group. Instead of painting on the canvas in front of her, she chose to move out of order and paint her images wherever she wanted. This proved upsetting to at least one person and annoying to another. Why did she feel she had to rebel? It was an interesting question and provided endless discussion for the whole group.

Painting this way does call for a certain degree of humility. Nothing has to be special or different or precisely executed, but again and again, this method asks for the best that can be done in the moment—no correcting, editing, or covering up.

When I first started to paint this way, I kept asking myself the same thing: "Is this art?" Finally I realized it was the wrong question. "Am I playing, taking risks, discovering new images?" The first query tried to put a value on what I was doing. The second cut right through any merit that I, as "the Artist," might want to claim, and asked what effect the process had on me and whether it was widening my experience.

To reach what is within you, you first have to let your Self go. Then you may begin to know the depths of another kind of strength.

YOUR OVERPROTECTIVE AMYGDALA

Ever wonder why some sound in the night makes you freeze like a deer in the headlights? Or why a sudden motion makes you jump out of your skin? That's your amygdala on active guard duty. As I noted in the introduction, the amygdala is one of the small structures in the limbic system, our "emotional brain," and its main job is to scan all incoming sensory information to determine whether or not we are safe. Once the amygdala is activated, we experience the "fight, flight, or freeze response," an automatic defense function that explains why we often act before we think.

When the amygdala perceives something as a threat, it raises our anxiety level such that attention is drawn away from other parts of the brain and into a stance for self-preservation. There is no time to deliberate or check the reaction. The amygdala has already sent messages to other systems to raise our blood pressure and heart rate and release stress hormones for action. Evolutionarily, we're hardwired to react before we can think the situation through. This was very necessary at one time—hesitate to act and you might end up as dinner.

For instance, in this often used example, imagine yourself walking along a wooded path when you suddenly spy a long, curved shape up ahead. Maybe it even

appears to move. This visual stimulus reaches the amygdala in a thousandth of a second, with the result that you freeze in place. You do this without any awareness of feeling afraid, as the emotion actually comes later via a different and slower pathway from the amygdala to the higher-thinking cortex. Here, the visual cue is analyzed for its accuracy. Is it really a snake or just a tree branch? In a situation like this, the automatic freeze could save your life. However, an act first/think later structure like the amygdala tends to take over much more often than is necessary in our current environment. As a rule, we don't run into snakes much anymore.

Unlike other cells, the cells of the limbic system do not mature over time. This means the fear mechanism remains unchanged as an automatic process, and we are often not consciously aware of what's going on. We like to regard ourselves as thinking creatures, but as neuroanatomist Jill Bolte Taylor explains, "Biologically we are feeling creatures who think."[2] And with so much activity in our brains, we don't always know why we feel the way we do.

Many fear reactions are based not on evolution alone (though the snake happens to be one that is innate to humans), but on past experiences that have been anchored in our memories from as far back as early childhood. In extreme cases, instead of just remembering a traumatic incident, the event may get relived when certain environmental cues trigger a reaction. One such example, cited in the PBS series *The Life of the Brain*, involved a man who'd been in a car accident. Long after the event, just the sound of a car door slamming would cause him to jump and set his heart racing as if he were back at the scene with metal slamming into metal.

Although the cells of the limbic brain never change, our higher cortical cells do as we age. These more mature cells are able to contrast incoming information with the limbic response, thus reevaluating the situation and choosing another option if necessary. However, neuroanatomists have been able to show that the two pathways that process the emotion of fear are not equal. Connections from the outer cortex to the amygdala are much weaker than those from the amygdala

to the cortex. This difference between the two message systems, researcher Joseph LeDoux says, may explain why once an emotion is aroused, it's hard to turn off.[3]

Psychologist and author Daniel Goleman similarly speaks of an "amygdala hijack," the sudden impulse that comes about under stress and causes us to make a rash and uninformed response. This too is a result of the overprotective amygdala. We feel attacked, so we lash out. We feel endangered, so we freeze. But rather than be hostage to our emotions, we can use them to learn about ourselves.[4]

Putting feelings into words has long been acknowledged as an effective way to temper our fears; however, science can now explain why it works and why we should do it often. Matthew Lieberman and his team at the University of California in Los Angeles studied the brains of thirty healthy people between the ages of eighteen and thirty-six as they responded to pictures of faces displaying a range of negative emotions.[5] Subjects were asked to select appropriate labels for each affect presented. The resulting fMRI data provided the first clear demonstration that affect labeling, as the linguistic process is called, disrupts the response of the amygdala to the presence of negative images. Not only does labeling dampen amygdala activity, but naming emotions seems to indicate an opposing increased activity in two regions of the prefrontal cortex—that outer layer of higher thinking.

In the painting process, we may not perceive dangers that make us want to actively run or stand and fight for our lives, but strong emotions do get activated and we can freeze. ("I *hate* this.") The challenge is to question the panic buttons that get set off as we make something that scares or even disgusts us. How can these feelings be so powerful over a bit of paint on paper? It may help to view these overreactions as distractions, trying to take us off track. More simply, they interrupt the flow. Questioning the emotions that are triggered actually engages those upper cortical processes, thus allowing us to choose another course of action. This is about seeing our feelings as messengers rather than taking them at face value. The emotion or block then becomes a tool for understanding, and not something we have to avoid or circumvent. Rather than saying, "I'm not going there . . . ," talk back with new words, using mantras or naming fears.

Exercise Introduction:
I Can't Do People

In the beginning, most participants in this imaginative work are very reluctant to paint a person. This is understandable, since it seems to test a basic ability to draw with anatomical accuracy, and no one wants to fail. Of course, we all know we possess a pair of eyes, a nose, and a mouth, but putting them together so they are recognizable? Ah, there's the trick!

My student Diana is often troubled by her own painted figures, because she thinks they always look "cartoony." In my mind that's a plus, although she doesn't yet see it that way. She's an artist and interior designer, so she gets held up by her inner art critic. But it raises a valuable question. Why can't our figures be like those in a comic strip? We *are* making up stories, and I've seen just how often the humor in an image will come to our rescue, making us laugh at ourselves when we need it most. That was the situation during one of my Saturday workshops as we began with the "Sticks and Stones" exercise that follows next.

One of the students, Mariel, showed up late, the steam of frustration almost visible due to an abundance of travel woes, all of her own making, she said. Mariel is twenty-eight, just starting a master's in art therapy, and makes a long train trip to Manhattan to attend class. She has determination, but is the first to admit that she's hard on herself.

After filling a page with small pipe cleaner–type figures, I asked her to pick one and add details—features, clothing, accessories. Where is the figure and what is it doing? Could we see something of the place? Does the figure need props for the activity? Are the other figures on the page doing the same thing or something different?

Even though I carefully set this exercise up as a fault-free experience, frustrations can rise quickly over first attempts, especially when it comes to depicting anything human. However, today Mariel's brush was moving nonstop and unhesitatingly. She

said later she knew instantly who the figure was and where—Mariel herself at the train station! After putting in black clouds over her head, she began playing with the other "people" at the station—a lady with a crying child, a Rastafarian resplendent with braids, a man with a dog on a leash, a cop flashing his badge, and lots more. By the time she had finished, she was laughing—at herself, at her story, at the little cast of people she'd created. What a perfect antidote to her earlier misery!

Like everything else in this experimental process, the ease of doing depends on your expectations and your ability to not take yourself too seriously. Are you working to make a lifelike portrait? Not even close. That's why we have cameras. Let's look instead to stick figures and smiley faces for permission to make it simple. If the great critic inside you raises its head over these first efforts, bring it into conversation by asking, "What's the worst that can happen if I don't like the image and decide to let it be?"

SECRETS OF A MASK-MAKING SOCIETY

I give tours connecting African studies with art in many New York museums, including the Metropolitan Museum of Art, for elementary-school youngsters. As I introduce them to the wonders of African masks, I marvel at the incredible variety displayed within just one museum hall. With fifty-four nations and more than a thousand languages, the African continent has good reason for such diversity. My favorites are the masks from Western Sudan, with their bold and earthy geometric patterns, because I already have a personal association with them.

I saw my first Dogon mask in the home of a fellow artist. Five hundred years ago, the Dogon people made

Antelope mask

their homes along the steep Bandiagara cliffs that stretch 125 miles, north to south, in the sub-Saharan country of Mali. One of the few groups to remain untouched by time, the majority of Dogon still practice animism (the belief that everything has a spirit) and use masks in their rituals to honor ancestors and ensure a good harvest.

As a longtime collector of containers, especially those made of wood, I was immediately taken with the boxlike structure of these masks, well before I knew anything about the geological area from which they'd sprung. Rectangular eyes seemed to mimic windows of the local architecture, as did the flat surfaces of the mask itself. That made me want to ask: Which came first, the building or the mask? While this question is more rhetorical than answerable, the similarities were not based on some committee decision; they arose the way natural art emerges best—preverbal and unaware of itself. Surely, here were "windows" to the soul.

Members of the Dogon's secret mask-making society, the Awa, create each mask just before the Dama ceremony, a collective funeral rite, thus ensuring the powers invested are fresh and active. Because of this, the Dogon people feel that each mask is imbued with something of the gods themselves. The men of the Awa seclude themselves within the caves of the high cliffs to carve and paint *Walu* (antelope) and *Kanaga* (a combination of mystical bird, crocodile, and the upper and lower universe), using pigments made from the elements about them—crushed rock for red, pulverized bone for white, and boiled berries for black. Without color, the masks would remain ordinary pieces of wood without life.

These secret mask makers draw their inspiration from the geometry of the surrounding rocky hills—all sharp angles and shadows. Like windows and doorways, the ears, nose, and mouth are also considered portals where inner world meets outer.

Exercise 1: The Mask of Possibility

In this exercise, we will take our inspiration from the secret mask-making societies of the world, which create some of the most imaginative, powerful, and decorative images *without* formal art training. Mask making in many African nations, for example, is an integral part of masquerades and rituals that celebrate funerals and honor ancestors. These masks are endowed with the geometry of place—rock, cliff, plant, and shell—and take their power from the animals of the area—rabbit, antelope, and crocodile. Rich material from which we may borrow freely.

Sample Mantra: "Something old and wise in me knows the way."

1. If you have not already tried turning the journal page in a vertical direction, this is the moment to do so.
2. Outline a large oval almost the size of the page.
3. In any way you know how, put in the features, starting with the eyes. Eyes can be simple dots.
4. The nose can also be a dot, or a curved or bent line.
5. The mouth can be made from one or two lines—one simple line, or one line each for the upper and lower lips.
6. Now ask yourself, "What other features could I add?" Think: ears, eyebrows, lashes, hair, dimples, makeup . . .

Hint: As you do this, you can have a particular facial expression in mind or no intention at all. Just remember to let whatever emerges from the brush be, whether or not there is a plan. We want to be very gentle toward these efforts. Try to avoid the temptation to fix them, cover them up, or do them over.

Simple mask face

Ask Yourself

Have you ever seen someone do "face painting" at a child's birthday party or carnival? Or, better still, have you had someone paint yours? It's a way to view the open areas on your face as you would look at an open field ready for some gardening.

Bigger areas like the forehead, cheeks, and chin invite invention. How might you embellish them with an image or repeated lines of any kind of pattern, color, or shape? Animals are often reflected in ritual mask decoration by imitating skin patterns or adding parts like horns, tails, and beaks. What designs do you like?

Last looks: This is the time to look at the whole picture and see if it needs any last touches. Could there be something on the head? In the hair?

Anything around the eyes—glasses? A monocle? What about around the chin line? Could something be growing out if it—hair, vines, leaves, ears of corn? What could we see around the mask? Every added detail takes us further into the process and expands our focus and meditation, so let your imagination go wild.

Adding some zigzag lines to face

Cat Costume. *Not until I was close to the end did I even know it was a cat. Once I added the red and orange paint at the top, I suddenly saw that the plain blue zigzag lines I'd made earlier were actually ears.*

Reflecting on Your Work

Like many exercises in the book, you could do this one over and over, and every time would be different. What I love about this process is how, in time, ideas and images evolve without your trying too hard. So often it's when I have nothing in mind, but add some impromptu color to a shape, that it suddenly "tells" me what it is. The color and shape will trigger some memory, or some piece of information will connect with another. This may not yet be your experience, but it is coming. Keep your mind open, and it will do the work we seek.

Cat Vacation. *This cat came about because I filled a shape with yellow paint, and then because I'd just been to the beach, I put him there too. Sometimes the next step isn't a struggle at all.*

Exercise 2: Sticks and Stones

". . . may break my bones, but words will never hurt me." I have always liked word games and still do. Although it now seems a tad gruesome, I remember with real affection playing the game "hangman." Maybe you do too. Let's just accept it for the easy lessons in anatomy and playfulness it provides as we explore making simple stick figures.

Sample Mantra: "This doesn't say anything about me. I'm just making cartoon figures."

1. Use your detail brush for this exercise.
2. We're going to fill the page with small "pipe cleaner" figures. Use any color paint and change colors as often as you want.

3. Before you start, consider the basic "body" parts:

 Oval or circle head shape

 One straight line for the neck and torso

 A horizontal shoulder line at the junction of the neck and torso

 2 lines for arms (shoulder to elbow, elbow to knees), extending from
 each shoulder

 A hand shape or finger lines at the end of each arm

 2 lines for legs (thigh to knee, knee to ankle), coming out of both ends
 of the torso line

 1 foot shape or line at the end of each leg

Hint: This may seem very simplistic, but believe me—it will become more refined with practice, because the surprise is that once you begin to let yourself experiment, you will get more courageous about how much you're willing to attempt. Also, you will actually begin to observe more from real life, noting the shapes of features like ears, noses, or mouths. As happens with so many things, once we are exposed to an idea, we just start seeing examples everywhere.

4. Paint a simple standing body with the above parts (as illustrated below). Start with the head and work your way down. Do not worry about accurate proportions (at this time or ever).

5. As you look at your figure, think about where the body bends at the basic joints—knees, elbows, wrists, etc. Now add a small circle or ball shape where these spots exist. Check your figure against the illustration below.

Stick man walking

6. Now make some action figures. Think about different actions for a pipe-cleaner person. Start simple, keeping in mind where the ball joints are. Make three or more such action figures, bending the limbs to indicate movement. If it helps you to put in the ball shapes, you can, but it's not necessary. Don't overworry this—it's play.

Action figures

7. Pick one figure and give it features and details—hair, face, clothing, what-
 ever you choose.

Ask Yourself

- Do you like your little people or not? Be kind—be respectful!
- Do they need a prop? A book for reading? If outside, maybe a bat, a ball,
 or an umbrella?
- What's under their feet? Grass? A trampoline? A Persian rug?
- Are the stick figures part of the same activity or is each one doing some-
 thing separate?

Action figures

Reflecting on Your Work

The questions I ask my students after they try something new are always the same two: What felt easy? What was difficult? To delve into that first question a bit further, ask yourself: What was easy about it? What was fun? Did you surprise yourself?

Regarding the second question, can you point to the place or places in the painting that felt hard to do? Was the inner critic interrupting you? Was there a moment when painting some part felt like a bigger risk? How did you keep going? Were you able to push past any limit that presented itself? If not, don't worry—you'll get another chance. Our blocks have a way of coming back, maybe even in the next painting.

Because the work is visual, we have a kind of "map" of the places where something occurred, whether it was an interruption or an aha moment. Take the time to reflect on these points to reinforce whatever breakthroughs and insights happened before moving ahead to the next page.

9

MYTH, MAGIC, AND PSYCHE

The collective unconscious contains the whole spiritual heritage of mankind's evolution, born anew in the brain structure of every individual.

—Carl G. Jung[1]

Time for a little review. So far on our journey, we have examined:

- Improvisation: working without a plan, making it up as we go along
- The value and power of images and image making as a means of learning about and leaning on ourselves
- The importance of accepting our ability at its own level
- Recognizing and using blocks as gifts
- Letting go of control and perfectionism

Each time we stay a little longer with any one page by either adding another visual detail or starting a new shape, we strengthen our ability to ride out any tension we might feel about letting images evolve in their own time and not hurrying to be "done." There is no race here, nothing to be gained by finishing quickly. In

fact, coming to know when you are done will be an ongoing process that will continue long after you've finished this book.

We are still in the process of giving our imagination "muscles" a workout. But then, what about that common, even incessant, worry about where to get that next idea? I made assurances in chapter 2 that we already have what it takes to paint in our journals and that every one of us possesses a personal visual library from which to draw. The page before us may be blank, but our inner resources are not. What does this really mean? Where do these images come from?

Our images come from different sources. On one level, we can call on the smells, sights, and sounds of past experiences that form our personal memory. But there is another well from which we may draw. On another level, before any of us even had a chance to store up memories, we were born with a source already inside us—what might be called the "psychological DNA" of the psyche.

According to the eminent psychologist Carl Jung, this "DNA" is made up of patterns he called *archetype*s. These archetypes tend to produce a certain set of images, behaviors, and perceptions that science is now finding are hardwired into our brains and are a part of all human inheritance. This means that without ever having to study the myths and stories of the world, we hold the models or prototypes of the main characters already within our psyche—the child, the great mother, the hero, the trickster, and the wise old man, to name a few. This primordial inheritance explains why societies all around the globe hold similar myths to explain the mysteries of the world.

Each archetype is not just the model for a universal role, but is also the prototype for the actual conflict or drama in which the character finds himself. Mythologist Joseph Campbell explored the drama of the typical hero in his book *The Hero with a Thousand Faces*.

Around the globe, heroic tales call for the hero to venture forth into a strange and unknown territory, encounter a series of trials, and bring back some spectacular gift to mankind. It is a story of transformation in which the hero must face something dark, discover unknown strengths, and give himself over to a higher end. For

example, in the Himalayan story of Buddha, Prince Siddhartha renounced his throne and retired from the world. While sitting under the bodhi tree, he faced down three temptations and thereby acquired enlightenment. He then returned to teach his people how to understand and ease their suffering. This personal growth is also an archetype.

Where do these primordial images come from? Jung believed they are the result of how early humans responded to natural, repetitive phenomena. Think about the cycles of the moon, for example, or the rising and setting of the sun. Humans everywhere created stories or myths to explain what they were witnessing but could not entirely comprehend. Hence, we have the sun and moon archetypes, like the Greek god Apollo and goddess Selene, and the Aztec sun god Huitzilopochtli and serpent moon goddess Coyolxauhqui. While most sun gods are male and moongods are female, in Japan they are portrayed as two sisters—the Sun Lady Amaterasu and Sukiyomi the Moon.[2] These characters are from different cultures and different eras, but they share commonalities because myths and legends are really the stories early man told to explain his own place in the world and his relationship to certain unexplained phenomena.

Jung believed these innate patterns are activated by what we encounter in the world. Here lies the source for that second level of images. When we find ourselves in certain situations, these prototypes or patterns inform us, unconsciously, of how to behave and help organize ourselves to the task. Take a first-time mother holding her newborn and looking adoringly into the infant's face. The natural instinct to bond is but one part of the pattern or archetype of the great mother goddess figure that nurtures all. Likewise, the hero archetype, mentioned earlier, may be called upon as a gymnast prepares to compete in the Olympics or as a ballerina approaches the stage. They must battle their inner dragons in order to be fully present for the performance to come.

How does this help us to paint images in our journals? As I've said before, pure art making, in which the focus is on the process and not the result, makes room for something else to come forward. Many of us think that improvisation is random

when it is not. What improvisation does is open a dialogue between the unconscious and conscious mind, allowing us to access all these archetypal images. It is in the actual doing—when we make the splotch, the dot, or the form—that we invite these symbolic figures to come forward. Our brush unwittingly paints something to which we respond. This may sound simple, but conflict can arise when we don't like what we see.

Conflicts happen because archetypal patterns contain not only all the wonderful qualities of humans, but also, to quote Jung, "The worst infamies and deviltries of which men have been capable."[3] These are often the very parts of ourselves we want to deny exist. So, you may well be saying to yourself, "I don't really want to make contact with infamies and deviltries, do I?"

I'd answer, "You might," and here's why: When I began painting from the imagination (as opposed to painting from real life), it was because I was certain there was more inside me that I wasn't able to access. As I've mentioned earlier, in my fantasies I imagined great, large paintings of incredible color. And my first paintings in this spontaneous manner seemed to be just that—a feast of colorful rhythms and strokes that poured out of me with little pause. However, I made a real discovery about what was limiting me in my creative work when, one day, I reacted to a figure I'd painted with an intense feeling of revulsion. I felt it with my whole being—this figure was simply "not okay." The woman I'd first painted had been so lovely, curled up amidst the sea and shells, like a water nymph. As I continued, I added yellow and pink circles to her skin, although I knew immediately that they were not decorative but were oozing sores. I wanted to take them back. Now as I gazed at the painting, "she" made me feel ill.

In the past I would have painted over the offending image or started a new painting, but not this time. This time I sat with it and let myself cry. I cried because she was so wounded and so vulnerable to the scabs and scars over her body. Hidden behind my "oh no, not that" rejection was real pity and a tenderness for her human condition. I didn't try to fix her or try to make the painting look better. I didn't try to analyze it for meaning. I just let it be and *that* was a huge leap.

To deny something that we don't like or that makes us feel uncomfortable is a common reaction. But when we can interrupt that reaction and instead approach with curiosity, we allow another piece of the psyche to reveal itself. It's natural to want only light, sunshine, and an idealized portrait to appear before us on the paper, but we are so much more than that. Giving form to all archetypal aspects—the wounded child, the magical child, the warrior, as well as the mother and the hero—makes us whole and more flexible about who we are. The devil and the angel, the trickster and the old crone are just energy coming through us. Their emergence on the page does not mean that we will act like them or that we are in danger of becoming them. The psyche never hands us something we are not ready for. In fact, releasing these energies makes us stronger, more flexible, and less subject to their whimsy. The more we can literally see the other on the page, the more objective we can become about these natures, rather than dismissive of the shapes of our fears, frustrations, and yes, even our successes. With more information comes a more reflective understanding of ourselves and the world we live in, of why others do what they do and why we do what we do. The images that show up unwittingly under the brush evoke reactions and feelings. This is what we seek and what allows us to engage in the discovery process.

What set Jung apart from others in his field was his belief that the process of knowing one's inner life was not to be reserved for clinical diagnoses but was an endeavor worthy of any individual dealing with life's everyday challenges. This was a very big break from the thinking of his time. Undertaking this journey of self-discovery allows for new choices to be made so we might all live our lives more creatively.

Whether or not we allow these images out when they arise, or even know how to access this cast of characters through that next splotch of paint, is the question. Here's another way to think about it: Jung tells us that the *persona* (Latin for mask in old Roman theater) is a psychic structure that we create to negotiate our everyday world and act the part of the employee, the policeman, the teacher, or whatever role we are playing. However, we forget we are so much more than the roles we play, and

if we overidentify with any one of them, it doesn't leave much room for invention or playfulness. What better place to try on another character than in the safety of one's journal? I am reminded of something a student wrote in his workshop summary after taking part in one of my classes: "Here I can just be." So just be. Let whatever wants to emerge just be, in whatever form it appears. Play all the parts.

CARL JUNG AND ACTIVE IMAGINATION

In 2009, a one-hundred-year-old journal that had been locked away became available to the world. It was *The Red Book* by psychologist Carl Jung. Large and highly ornate (the cover and leather binding are a deep red), the journal is written in a calligraphic hand, with the title inscribed in gold; what actually lies within is an amazing and personal record of a troubled period during Jung's life. At first, he used only words to describe his experiences, but he found them "clumsy." He then turned to image making to deepen his exploration and portray the battle in his mind and psyche through painting and drawing.

It was during this period that he developed a meditation technique he later called *active imagination*, whereby the content of the unconscious mind gets translated into mental images and narrative. Still used today in the Jungian therapeutic process, it is a means for visualizing and embodying unconscious issues or images by letting them act themselves out in story form with as little interference as possible from that gatekeeper—the analytical brain. When, in 1913, Jung began hearing voices, seeing visions and fantasies, he made a decision to strive to keep his conscious mind from blocking out the fearful imagery his unconscious was revealing to him. He felt these strange and sometimes terrifying images held messages that would tell him what was going on. Rather than repel them, he encouraged their appearance via writing and painting.

When I discovered active imagination, I found value in the process used for creating conversation between myself and what appeared on the pages of my journal. It helped me separate myself from some very strong demons and what I thought of at the time as very ugly images. Later, when I looked back at these pages, I would remember the difficulty encountered but no longer feel the intense judgment. In the end, far from making me feel inept because they were not beautiful, the images made me feel a new sense of power and authenticity about my creations.

I should advise you to put it all down as beautifully as you can—in some beautifully bound book. It will seem as if you were making the visions banal—but then you need to do that—then you are freed from the power of them. . . . Then when these things are in some precious book you can go to the book & turn over the pages & for you it will be your church—your cathedral—the silent places of your spirit where you will find renewal.

—CARL G. JUNG[4]

Exercise Introduction: Tapping into Your "DNA"

Examples of archetypal characters are all around us. We never have to look far. Often woven into stories, they're in the books we read, the movies we see, and especially in our dreams—those larger-than-life characters that are just too good, too evil, too weak, or too all-powerful. Story is primary when using active imagination in our painting work. It may be helpful to think in terms of a play. As you look at what you've painted, who are the characters? What might they say to one another or to you?

I've engaged in this exercise many times myself. On one such occasion, after drawing a huge, writhing tree under which a grandmother and child appeared together, I identified four characters: the grandmother, the child, the tree, and myself (even though I was not in the picture). In the conversation that ensued, I heard words of encouragement and wisdom at a time of difficult transition in my life, "spoken" by my long-departed grandmother, one who'd been so supportive of my creative development as a child. That was magical, like my own fairy tale.

While archetypes run the gamut from goddess and wise old woman to goblin, we're going for the gusto here—the darker rather than the lighter characters, as these are the shadow figures we'd often rather not see. The first exercise may seem similar to the "Paint Your Critic" exercise in chapter 7, but with a big difference— we seek not a critical voice but a way to hang a face on the fears that grip us a little too tightly. The nameless things that go bump in the night. Do you think you can't do it or are you more afraid you will?

One of my students arrived at class one evening having come directly from a New York Public Library exhibition on Mary and Percy Bysshe Shelley. The figure of Frankenstein's crudely fashioned man was much on her mind and seemed a perfect example of the way in which we are both fascinated and repelled by monsters. (We certainly still continue to be drawn to vampire figures, and maybe for the same reason.) Different from other beasts, Mary Shelley's creature arouses our sympathy for the situation in which he finds himself. Hostage to a fate not of his own making, he is both monster and innocent. Perhaps we can use this sympathetic attitude toward the monsters that appear in our dreams or beneath the brush. You might discover they lose their bite once reduced to paint and paper. Rather than hide them or make them go away, let's invite them into being and hear their stories.

THE COLLECTIVE UNCONSCIOUS
MEETS NEUROSCIENCE

Carl Jung viewed the unconscious as being made up of two levels: the personal and the collective. He believed the personal unconscious is formed by our life experiences, lost memories, and sense perceptions, while the collective level—our focus here—houses the archetypal material mentioned earlier. Now science researchers think they may be able to locate where these collective patterns can be found in the brain. Neuroscientist Jaak Panksepp has identified seven basic emotional systems located in the subcortical regions,[5] an ancient part of the brain that is older in terms of human evolution.

Panksepp believes his seven emotional centers—seeking, rage, fear, panic, lust, care, and play—are in harmony with Jung's archetypes. These emotions guide our behavior and reactions to outer stimuli in much the same way as Jung's typical archetypal patterns. Think about the emotion "care" in terms of the great mother or the "play" factor as a match for the child.

One of the subcortical areas that houses emotions is the amygdala, which I discussed in chapter 8. (In that chapter, we looked at the fight-or-flight response in the brain in "Your Overprotective Amygdala.") Along with fear, Panksepp found the emotions rage and anger to be associated with the same area of the brain. To me, the latter two emotions line up with Jung's archetype of the warrior, a dark and sometimes irrational figure exemplified in the Hindu goddess Kali, keeper of time and death.

Whatever science and psychology makes of these findings, what fascinates me most is the acceptance in the scientific world of unconscious mental processes. "There is no doubt any longer that purposeful brain activity takes place without the conscious awareness of the individual," wrote Jungian analyst Arthur Niesser.[6]

Exercise 1: Creature from the Black Lagoon

Taken from the movie of the same name, this colorful phrase has become part of our popular culture—a fact that I love. ("Ugh, my skin feels like the creature from the black lagoon.") Compared to the digital creations in films like *Alien* and *Jurassic Park*, or the creepy Pale Man in *Pan's Labyrinth*, the creature's lack of sophistication or scariness makes for very campy fun. Laughter has its usefulness in deflecting fear as we approach this exercise. As with every page we do, we are just playing. See where the brush takes you.

Sample Mantra: "It's only paint and paper!" (This one warrants repeating.)

1. Start by making a large shape with your brush in any color. Let the creature ooze out of your brush. Think head, tail, claws, fangs.
2. As with making people, go back to the head and add whatever details it needs. There are no limits to the number of eyes it may have or the size of the mouth.

Hint: Make as many eyes or noses or mouths as flow out of your brush. Keep making them until you feel you've run out of juice.

3. Do the same with appendages—arms, legs, tails. Start with whatever that first blob provides and then add anything that you feel needs to be there, even if you don't want it there. (Make that *especially* if you don't want it there.)
4. What kind of skin does it have? Is it rough, scaly, thorny, or more like cottage cheese? Give it your best shot.

Not one but two creatures live in that old lagoon.

5. Where is it and what is it doing? I recall Aunt Ada of *Cold Comfort Farm* (a very, *very* funny British film) saying over and over, "I saw something nasty in the woodshed!"

Ask Your Image (Active Imagination)

Use these questions to engage in a dialogue with your images. The conversation may guide you toward the next image or detail on the page.

- What are you?
- Why have you shown yourself to me? Why today?
- Are you alone?
- Is there anything you need?
- What will happen next?

*My creature feature knows no bounds. This one
leaves death and destruction in its wake.*

Reflecting on Your Work

Whether your creature turns out to be more humorous than terrifying is not so critical at this point; only the intention remains useful. This exercise will prove its value in the context of a real block. The next time you are painting and feel yourself in the grip of some huge fear or over-the-top anger, try to pause and identify the feeling in some way. Where do you feel it in your body? What color is it? What do you feel it wants to do to your picture? I have used this "creature feature" many times to make visible an event that's happened in the day—whether I'm aware I'm overreacting to some frustration or setback, or whether I'm in a very real situation in which I have no control. Rather than tear up the page, I will give my creature a very dangerous-looking pair of scissors. I will let it cut up something in the picture. On

other occasions, the scarier or more horrible I've tried to make the beast, the more elusive and ridiculous it has appeared, making me laugh at myself and ease up on my grip. That is the magic and transformative power of the image-making process.

Exercise 2: Return to the Cave

There is something elemental about a cave, taking us back to our beginnings and the first primitive rock paintings. Close your eyes and see yourself on a path. Is the path sandy or full of leaves, flat or hilly? Find your cave and paint the treasures you imagine inside. You may choose to be outside or inside the cave, or both, as all views are possible.

Perspective, as in all our pages, is of no consequence.

Sample Mantra: "Everything I need is already inside me."

1. Somewhere in the middle of the page, make the outline of an entrance. It can be wide or narrow (a wide, upside-down U-shape works well), but the length and height are up to you.
2. Now you are either outside the entrance looking in, or inside looking out. As you play with the possibilities, use whatever comes to mind. Borrow from your knowledge of human evolution or take the painting into the present and add what you want.
3. *If you are inside:*

 What do you see inside the cave? Start simple. Think:

 Tools

 Supplies

 Recreation

 Elemental needs for survival

 People: What are they doing?

> Critters
>
> Cave paintings
>
> Or

4. *If you are outside:*

> Where is it and what is it near (mountain, forest, ocean, frozen tundra)?
>
> Is there a path leading up to the opening?
>
> Does the entrance have a sign or mark of some kind?
>
> Who/what is nearby?
>
> Do they live there or are they strangers?

Inside the cave looking out

- What surprised you about what appeared? Is there anything there that you can talk to—a natural or man-made object, a creature or human being?
- What does it want to tell you?
- Does it know what will happen next or what is needed to make the story complete?

Reflecting on Your Work

Sometimes it is helpful when trying to "talk" with an object to think of treasured family heirlooms or mementos and the stories they could tell of their owners and the world in which they were used. Even a button on a favorite jacket may be thought of in terms of the places it has gone and the things it has seen. As children we did this kind of imaginative play so easily. As a youngster at the family table, I was always turning my forks, spoons, and knives into people and making them act out stories. We just need to warm up those engines.

10

WORKING THE EDGE

We have left the well-tracked beaches of proven facts and experiences. We are adventuring the chartless seas of imagination.

—Anne Morrow Lindbergh[1]

We began with the concept of the unplanned painting and a development of trust in the unknown, learning to sit with uncertainty until an image emerges and stretches the muscles of our imagination. Each weathered episode of ambiguity strengthens our ability to accept whatever form a new idea takes. How do we keep this process moving ahead? How can we improve? What is it we must come back to each time we approach the page?

As with any process, you have to start from where you are and accept that, whatever your first steps, they are good enough. To make progress—that is, to widen and deepen each painting experience—means to come back and lay yourself on the line. You have made a tacit agreement to begin taking risks no matter how small. Each time you risk one thing, you are bridging the way toward a next time, and with practice, a series of such moments. It's an exhilarating experience that can also bring you in touch with a range of emotions, from dark to light.

If you continue to paint only what you know or what is already planned out in your head, what has been discovered? Creativity is about venturing into the unknown, about discovering something new. Here I differentiate between what is new for one person and what is new for someone else. Newness is personal and subjective. Each of us has his or her own river to cross. The point, after all, is to find out what you don't know about yourself. You want to find whether your imagination is being held in check out of some fear or by some arbitrarily applied set of rules.

The focus must always come back to how much more you can do. This is how to move ahead, the measure of your progress. To work the edge is to take each painting one step further than the last. When there are difficulties, questions need to be asked: "What is stopping me?" and "What am I really afraid will happen?"

Is your fear about:

- Making a mess?
- Being seen as silly?
- Not being good enough?

What if the images your imagination brings you are not the stuff of happy endings but darker fairy-tale material, violent or even sexual in nature? Here we can dig into the myths and lore that so fascinated both Carl Jung and Joseph Campbell. Most of us know the Disney version of *Snow White* and can visualize the wicked queen. However, she was rather tame next to the stepmother in the Grimms' story "The Juniper Tree," who lops off her stepson's head and then sets her own daughter up to take the fall.

Considering that brutality, it might surprise you to learn that many of the fairy tales we grew up with are cleaned-up versions of the originals. The first tales were earthy and sometimes downright obscene. The evil ones—the witches, hags, and goblins—were not split off from their fuller natures as were the later versions pro-

vided by the brothers Wilhelm and Jacob Grimm. Characters were not all black or all white.

Characters like Baba Yaga, an old Slavic hag whose log cabin danced about on chicken legs, were both dangerous and wise. Kidnapping and enslaving children in one story, she might be found in another story guiding a hero on his quest, supplying him with magical gifts and words of wisdom. These characters were both good and evil, young and old, givers of life and death. That is the natural order of things—the inherently dual nature of the universe as characterized by the Asian symbol of yin and yang. In another example, Shiva, the male Hindu god of death and destruction, is balanced by his marriage to the feminine and gentle Parvati, the goddess of love and devotion.

Many students shy away from any violent or sexual imagery that emerges under the brush. This may result, in part, from a fear of what someone else will think, but it is also about old taboos that we might feel have no place in a private journal. I encourage students to understand this as just another form of energy passing through the brush, although one that rarely finds expression in the everyday. The images we create neither define who we are, nor imply a disturbing meaning. Express it, and it is there in the moment and then gone.

Such an experience happened to my student Lena during a women's painting retreat as she was trying to make an image look a certain way, but the brush seemed to have other ideas. As we gazed down at the page in question, she told me how she'd begun painting with a vision of a delicate, angelic being in her mind—a woman radiating peace. Instead it had turned into a large figure with heavy breasts. "I just can't get away from them!" she said about the breast images. They had first appeared earlier in the day during a clay warm-up exercise. At the time she intentionally rubbed away the unwanted clay, but here were the appendages again. Making something go away does not work. If it needs to be there, it will revisit again and again. Lena found herself laughing and the frustration melted away.

How rich and powerful would it be if we embraced all the images that emerge as

essential parts of the whole experience—the ordinary, the beautiful, the heartbroken, the monstrous, and the sensual? To do this, it's essential to keep a sense of humor about ourselves.

Creativity is essentially the brain making connections between unconnected data. And that is a big part of what makes humor work as well. Brain-imaging studies have shown that, along with activating areas associated with language processing, laughter stimulates regions known as reward centers, releasing dopamine. No wonder we feel better when we laugh! In the Greek myth of Demeter and Persephone, a mourning mother is able to move past her stasis only through humor. It's an important model for us, in the painting process and in life, of the healing nature of laughter.

How is it that as a culture—not to mention creative human beings—we think we can keep only the neat and beautiful, while denying or even tossing away the rest without consequence? How can we expect an endless supply of only positive images and thoughts? This is not how the creative process works. Fairy tales and other such stories were passed down to children as an attempt to acknowledge and teach about the light *and* the dark.

It all comes back to balance, always balance. In this process, I've advised you to separate yourself from any meaning imposed on what you paint. You are not what you paint but are rather the conduit for the energies passing through you from which these images arise. As soon as you judge them, a vital connection to the process is compromised. Thinking too much about what you are doing interrupts flow. This is the yin and the yang of painting. Finding a more welcoming attitude toward a fuller spectrum of images will help you reach the creative source. You paint darkly so the light may come.

A FUNNY THING HAPPENED ON THE
WAY TO THE RIVER STYX

Most of us are familiar with the Greek myth of the agricultural goddess Deme-ter and her daughter Persephone, who was abducted by Hades, Lord of the Under-world.[2]

The following is a version of this same story but with a twist—one I'd never heard until I discovered it in the works of mythologist and lecturer Joseph Campbell[3] *and Jungian author and storyteller Clarissa Pinkola Estés.*[4]

Once upon a time, when winter was as yet unknown to humans, two goddesses, Demeter and Persephone, watched over the crops. Although plants followed a natural life–death cycle, no field ever lay barren.

One day, as Persephone roamed the field picking flowers, the earth suddenly opened up, and the dark god Hades appeared in his golden chariot. Ignoring Persephone's pleas for help, Hades carried her off to his kingdom below and made her queen of the underworld, home to the dead. Meanwhile, Persephone's mother, Demeter, having heard her daughter's desperate cries, searched for her everywhere for nine days and nights. Beside herself with grief, Demeter could no longer eat nor drink. In her sorrow, all the crops withered and the fields lay barren, as she no longer took care of the life around her.

As she wandered lost and despondent, not knowing which way to turn, Deme-ter came at last to a well. While she sat there, inconsolable, unable to figure out what to do next, people from the village came forward to comfort her. All was for naught until a strange little creature appeared before the great goddess. Old Baubo, herself a goddess, was small and headless. As she began to dance about, she lifted her skirts to reveal her naked body underneath. Her nipples were her eyes and her vulva was her mouth. In that moment of bizarre revelation, Demeter laughed aloud and her laughter broke the spell of grief that held her immobile. She "awakened" to a course of action—she would go to the sun god Helios, who sees everything. From him she learned where Persephone was and that Zeus had been

Baubo

involved in the plot. Only then was she able to negotiate a compromise with Zeus and Hades: Her daughter would spend three months of the year with Hades and the remaining nine with her.

In this story, Baubo is an ancient goddess of obscenity, and her dance serves an important function. The sight of Baubo's lewd movements catches Demeter unaware and presents an unlooked-for point of view. This view is so out of the ordinary that before Demeter can think about it, she reacts with laughter, which spontaneously releases grief's paralyzing grip. I love this motif and hold it as a model for when I take myself too seriously. We, too, can move through emotional blocks via some unforeseen and amusing image.

Exercise Introduction: Ignorance Is Sometimes Bliss, or the Art of Unknowing

At any given moment, our inner censors stand ready to take over and tell us, "I know."

I know:

- What I like
- What is taboo
- What is ugly
- What doesn't make sense

What it *doesn't* know is how to wonder and be curious. An advantage that students who come to me without art training have is that they don't know the laws of color theory or the methods for drawing anatomically correct figures. They are free to exaggerate the length of a limb or choose colors in any combination, although they may need encouragement to do so. How then can we use the lesson of the untrained eye to open our views toward other standardized values? The secret lies in questioning these inner censors. One simple response is "I don't know what this image means," which in fact you may not. Either you haven't gone far enough with the image, or there is the possibility that you will never know what it means. So many of my pages don't reveal what they are about. They are but a prelude to the one that does reveal itself.

IMAGINE YOUR BRAIN LAUGHING

There's no mystery about the way laughter makes us feel, but besides the obvious amusement factor, science is finding that it actually gives our immune, cardiovascular, and endocrine systems a boost too. This human mechanism not only helps us cope with stress, but it also helps to get our ideas across and attract partners.

While we share with the animal world the ability to laugh and smile (studies have really been done in which scientists tickle primates), our ability to under-

stand a joke or find something funny is a decidedly human trait that has only recently come under scientific study. We know a lot more about pain and fear, because no one has ever felt the need to find a cure for the funny bone. But with the advances in magnetic resonance imaging, science is better able to see which neural areas may be responsible for our humor appreciation and the physiological and psychological benefits we receive.

Humor works because it involves an element of surprise, an unexpected twist (think of Old Baubo). According to the spring 2010 issue of *On the Brain*, a Harvard Medical School journal, there are three phases involved in any humorous experience.

1. Listener encounters something unexpected—the twist (which might be the punch line)
2. Listener then tries to make sense of it
3. Listener decides whether it's funny or not (and laughs or doesn't)

Although this list suggests an active listener, all this happens very quickly in the brain without our having to tell it what to do or in what order to do it. From the very first line of a joke, the frontal cortex begins working to make sense of the incoming sensory information. As we hear the punch line, the frontal lobe looks for patterns to resolve the twist.

This lines up with the findings cited in "A Gamma Spike of Insight," in chapter 7. Just before an insight occurs, the left hemisphere concentrates on the facts given while the right side scans remote memories for relevant material.

Further studies on humor now reveal that another part of the brain is engaged when we laugh. At the Stanford University School of Medicine, a team of researchers gauged the responses of sixteen healthy adults, ages sixteen to twenty-two, to funny and non-funny visual cartoons.[5] As the study subjects viewed and rated eighty-four cartoons by pressing a button, researchers examined the correlations between blood movement and humor intensity.

The fMRI scans confirmed areas already known to be associated with humor, like those in language processing. But they also revealed a new area affected. For the first time, humor was shown to involve a network of subcortical regions, the key parts of which are known as reward systems, including the nucleus accumbens and our friend the amygdala.

Although the amygdala, as we have seen, is more often associated with negative emotions, here it plays a major role in pleasure through the reward system and the delivery of dopamine. Injury to this structure has accounted for memory dysfunction and depression. Another of these structures, the nucleus accumbens, also gets involved at the emotional level to access the pleasure of the story and trigger the laugh, thereby also releasing dopamine as the "reward."

While earlier research had indicated the involvement of the human reward system in humor, this study revealed a marked increase in activation of these dopamine-enriched structures as subjects viewed funny cartoons as compared to non-funny ones.

What does all this mean for us in our journal work? Don't take yourself too seriously. Find the humor in yourself or in your painting and you will break through all the spells that bind, helping to unleash new insights. It's good for your neural health.

Not only that, but researcher Karuna Subramaniam and her colleagues at Northwestern University have found that you are more likely to have an aha moment when in a lighthearted mood.[6] So let yourself be silly. No one's looking here. No one cares. I'm not one to laugh much at regular jokes, but when my sister and I get together, we laugh our heads off over the most ridiculous things—usually our bodies. Well, the body is pretty funny. Just saying the words *nose hair* can really set me off. What does it for you?

Paint the idea that makes you laugh out loud.

Exercise 1: Inside Me / Outside Me

This is an exploration of images that symbolize what you feel is hidden inside yourself, as opposed to what you think the world sees on the outside. Like the mask-making workshops I talked about in chapter 8, we can use Jung's ideas about the persona or the "face" we present to the world and how it stands in contrast to the private, hidden side. In this exercise, we'll use two circles to enclose images, or brushstrokes that evoke these two parts.

Sample Mantra: "I am not what I paint."

Read through the exercise steps first.

1. Setup: The two circles or face shapes you make can be done on one page or two. You may also choose to do one shape inside the other to better illustrate the inner and outer natures of the exercise. There is no one way to do this.

Side by side on the page

One shape inside the other

2. Express your answers to the following questions in images, symbols, or made-up shapes. They are a guide—use as many or as few as you want, or make up your own.

3. The Outside Circle: The "outside me" may indicate favorite interests, career, and/or relationships.

Ask Yourself

- What do I like to do?
- What roles do I play?
- What do I think of myself or want to show of myself to others?

Being grandma is the best.

4. The Inside Circle: The "inside me" suggests private yearnings, feelings, or memories.

I don't much care for the wrinkles that come with it.

Ask Yourself

- What do I care about? Whom do I love?
- What do I dream of doing, having, seeing? What or whom do I remember?
- How do I feel? What do I feel like under my skin?

Hint: One state may be calm while the other more active. And of course this changes all the time, so there is no one answer. Just remember we are playing, always playing.

Reflecting on Your Work

The mantra I chose for this exercise, "I am not what I paint," may seem contradictory to an exercise all about how you perceive yourself. It is to remind you, however, that whatever you put down on paper today is not all that you are. It is an incomplete snapshot at best and will change to some degree every time you paint. One painting cannot ever be the definitive "you." As with the student who worried about the breast images, our painted images can provide a laugh and a release. Our perceptions about ourselves may be suspect and in need of some perspective or a playful tweak here and there.

Exercise 2: Throwing Your Cares Away

There are moments when everything can just seem too much. If one more problem shows itself, we'll go screaming into "that good night." At such times, we need to set our burdens aside so we can rest, renew ourselves, and think clearly again. Some do it through sleep, a run, a bike ride, or by making a list on paper. Visualizing and painting the load you're carrying can provide a real release too. What do you want to keep and what do you want to let go?

In painting, we can "toss" it all onto the page. All we need is a container, some symbols for the weight we are carrying, a place we want to throw them, and maybe an arm to do the deed.

Here's how to start:

1. Choose and paint an open container—a sack, a box, a trunk, a shopping bag, a tote, a laundry basket.
2. What's the load you are carrying?

You can either paint some simple images of the worries themselves—a car with steam coming out of it, a broken washing machine, etc. . . .

Or

3. Close your eyes and do a body scan like the one you did in chapter 7. When you find a sensation, ask yourself: "What does it feel like? Is it heavy, cold, hard, squirmy, queasy, tense, hot, rumbling, boiling?" and so on.

Now conjure up an image or two to fit this sensation and put them in your bag. (For example, rocks, boulders, or lava can symbolize heavy, hard, or boiling.)

Ask Yourself

Who is going to throw this bundle away? If you don't know, let your brush decide. Start with a head and then make a simple body. Let it be what it

Bad Day at Black Rock Beach

wants to be. If you feel you don't have enough room, so much the better. Squeeze the body in by making some parts smaller to fit the space you have. It doesn't have to be proportional. Where shall it be thrown—out to sea, on top of a garbage heap, into a big hole? Just show a part of this on the page or on the next page over.

Reflecting on Your Work

Was it easy or painstaking to come up with items for your throwaway bundle? Did you need more than one container? As with many of the exercises in this book, this casting away does not have to wait for its own page. The act of filling some container with the "garbage" of life might work during the next block or when the critical mind is laying on one too many injunctions—"You can't do that"—or interrupting with a list of other things you should be attending to rather than painting some "silly" page. One of my students had the wash basket already in her painting so that when she felt herself getting burdened by self-judging thoughts, she had the perfect place to lay down her "load."

11

IT'S OVER WHEN IT'S OVER

It is good to have an end to journey toward; but it is the journey that matters, in the end.

—Ursula K. Le Guin[1]

At this point in our journey, we've learned how to deepen the painting process and keep it moving along by revisiting the content, asking questions, and borrowing ideas from a variety of sources. But how do we know when we are actually finished and ready to start a new page?

Like so many things, there are no hard and fast rules here. Determining when to walk away and leave the painted page can be a subtle and delicate matter. It goes back to asking more questions.

Do I want to stop because . . .

- The feelings are too intense—I hate it, it's scaring me.
- I don't like what I've done.
- I'm too tired to go on.
- I'm bored.
- There's nothing else there.

Or . . .

- I have a feeling of completeness (even if I don't like it). I'm not walking away with any big emotions left hanging.

If, as in the first five responses, there are any lingering doubts, they need to be checked out. You may need to keep going. What might still be waiting to emerge? Very often fatigue, boredom, or frustration comes as a result of having to expend energy to hold off some unwanted image or feeling. There's a big difference between stopping because there seems to be nothing more you can do and stopping because everything has been said.

Of course, every painting has its own course to follow. Not every page will be thick and brimming with detail, nor will they arouse the same intensity of feeling. Some pages are gentle meditations, while others feel like war as energy flows and stops and flows again. Some days we come to the page with a heavy weight upon us, and sometimes we just wander around. Once again, it may come back to intentionality. What do I want to happen here, today, as I paint? Do I want to release something that is bothering me? Am I willing to sit with the tension as my brush finds its way?

There is a natural tendency to want to back away from unpleasantness or to leave a page too early, before giving ourselves time to dwell and discover the antidote to a painful feeling or the next step in the story. Staying longer with a journal entry strengthens our focus and gives us the time necessary to discover what blocks stand in the way and how we might move through them, not by trying harder but by playing differently. Think back to the story I told in chapter 2 of those two four-year-olds painting the dirty river and the giant crab. Rather than be eaten by the crab, they provided a way out by creating the Joy Path. We too can rescue ourselves from setbacks by imagining and painting the next step.

Carla was working on the "Organic Painting/Branching Out" exercise (in chap-

ter 6) during her second class, and frustrations were rising as she struggled to come up with more ideas. At one point, a strong feeling of "too muchness" kept her frozen and unable to add even one more detail.

How could she move through this block? Was there an antidote available? As Carla listed aloud the destructive things she could do to the page in order to feel better, an image of a boot stomping through the morass came to her. While actually destroying images on the page or tearing up the page itself would only create more problems, portraying a single boot would not. "Make the baddest boot you can," I advised.

That kept her going through the end of the session, but during our next class, Carla again had had enough of this exercise. "How do I know when I'm done?" she asked. I pointed out that there is a big difference between leaving a painting because it's complete and leaving it because you've had enough of the struggles of that particular page. Perhaps there was some way to add something that would give a sense of completeness.

As we looked down at her branch work from the previous week, Carla said she saw them as cracks in ice. What ideas did ice suggest? Skating, hockey, walking on it would be dangerous . . . but trying to make this picture realistic seemed to be limiting possibilities rather than opening them up. When brainstorming together provided no route back into the process, I suggested she reach for a color, any color, and add a shape or simply outline something already on the page, disregarding subject matter. Without hesitation, Carla's brush picked up some green and put it to paper. The mark quickly became a turtle and then a turtle wearing a hat and scarf. She had been reading about the Amazon recently but hadn't felt that a creature from that climate would fit into the ice world she had made. But it did. She'd had the answers she needed all along, but logic told her it was no go. Getting past those "logical" limitations was enough—now she could leave the page.

While finding resolution to the issues that emerge when coming to the end of a page is desirable, we can't always succeed. Rest assured that limits have a way of

repeating themselves. What doesn't get resolved on one page will resurface on another. The painting process has a way of seeking these things out. You might be thinking, "But I already dealt with my need for the picture to make sense or the fear of making something ugly," and I'm sure you did. The fact that the issue reappears does not detract from the value of that last exorcism; it only indicates that there is more work to be done.

I was working on a page where the main image was some sort of clown or juggler. When I returned to it after a break of a few days, I found myself struggling against an inner voice that said the painting was not cohesive. It didn't make visual sense. Where was his other leg? This is not a new issue for me, but rather one that raises its head from time to time. I knew the more I tried to clarify the figure, the more elusive the wanted outcome would be. I decided to outline some of the existing shapes in black instead. I'd discovered long before that using the little detail brush in this way keeps me going. I wanted to be done with the page but knew it needed something more. What that was just wouldn't come to me.

This experience was not about making the clown more anatomically correct or trying to make the picture look better, but about leaving something undone. Although I never advise staring at a page and waiting for inspiration, stopping to look for what might be needed is advisable, especially toward the end—as long it's just for a few seconds. As I looked at the paper, my eyes rested on some small purple fish I'd added in one corner. All this time I had been holding back from adding more, but now I wondered why. The only way to know was to test it out by painting a few more across the page.

As I did, an inner voice asked, "Are there even more?" Yes! I felt my energy rising as I added yet another string of fish across the clown's body. This led me to add eyes and to paint smiling mouths on all the fish. I knew at that moment I had resolved the conflict I'd felt earlier. I was happy and knew that I was done. As I looked down at the painting, a title popped into my head: *Clown Fish*.

"Oh, I'm so funny," I thought.

My "clown" fish

Every time we navigate a block on paper, a little room inside us gets bigger. We can call that room the heart, the mind, the soul, or perhaps more likely, a combination of all three. More room translates into more space for us to move around in, as we are less limited by old ways of thinking about ourselves. More room creates more resourcefulness supporting the energy needed to meet each new impasse. If it seems amazing that each painted image, shape, tree, person, or creature can make this happen, that's because it *is* amazing. The ability of the brain to rewire itself or create new neural pathways is extraordinary.

The act of stretching ourselves out of our comfort zones and meeting new challenges creates new neural pathways. Each page provides its own set of hurdles to work through as we try to flesh out details and not hold anything back. As we press against old taboos or get them to step aside, we activate neurons that control and

drive that action, and they fire repeatedly. The more frequently they fire, the more the neurons grow and move toward other neurons. They reach out, connect, and talk to each other. Suddenly we've got a buzzing network working for us.

This is an extraordinary journey, and you've only just begun.

A BUZZING NETWORK AT WORK

To understand how amazing our buzzing networks are, we need to take a quick look at the structure and workings of a neural path. Neurons or nerve cells reside in the gray matter, our outer cortical bumps. What is striking about these neurons is their interconnectivity, their ability to send information between all the cortical lobes and the deeper limbic brain. Communication happens by way of neural fibers or "wires" extending out from each neuron, which reside in the white matter. No action taken is executed by one area alone—we truly use the whole brain.

Information travels from one neuron to another in the form of a signal or impulse. The impulse is brought about by the movement of chemical particles called ions, which possess an electrical charge. The wave of electricity now leaves the neuron body by way of the axon, an extending fiber that meets with the dendrites of the receiving neurons. While each neuron has only one axon, it may possess thousands of dendrites, making it possible for any number of hookups with other neurons.

Although each axon is met by the dendrite of the receiving neuron, they do not actually touch. This space between nerve cells is what we call the synapse. To make the leap between the two neurons, the impulse switches from an electrical to a chemical transmission by releasing a chemical messenger or neurotransmitter, such as serotonin, for example. Once across the gap, the impulse returns to electrical transmission to continue on its way to another neuron in the network.

The fact that neurons are not tied to one another but have this tiny space in between is no small thing. That gap allows our neural pathways to form and re-

form, to hook up in new pathways in order to accomplish different tasks, to learn new ones or to discard a pathway when it's no longer used. This ability of the brain to rewire itself is called *neuroplasticity*. Physicians are making use of this process to help people regain losses due to strokes, dyslexia, post-traumatic brain injury syndrome, and some cases of blindness.

Neuroscientists at Wicab, Inc., an electromedical equipment company in Madison, Wisconsin, have developed a device that lets the blind see using their tongues. Still in its early stages, the BrainPort uses sunglasses equipped with a video camera. Instead of traveling to the eyes, the incoming visual data is sent to a handheld unit that then changes the data into electrical impulses and transmits them via a "lollipop," or electrode array, that sits on the wearer's tongue.

Ordinarily, incoming visual information is sent from the eye to the visual cortex at the back of the brain via the optic nerve. The BrainPort, however, retrains the brain to process visual information differently. The electrical impulses sent from the handheld unit to the lollipop stimulate the tongue, which then sends the visual information via a different pathway to the brain stem and then on to the touch center, eventually reaching the visual cortex, where the brain learns to interpret touch as sight.[2]

After a short period of practice, blind subjects have been able to navigate space—locate obstacles, find doorways and elevator buttons, even recognize letters and numbers. This is an incredible example of the brain's ability to rewire itself.

Exercise Introduction: Asking More Questions

As you may have noticed by now, this process is one of constant inquiry. Whether we need to determine the next painting step, identify the block being activated, or

understand intentions underlying the process at any given moment, asking questions moves us forward. Forming those questions on your own, like everything else, takes practice. The questions found in these following two exercises and in the list in the Resources section are useful tools, but as your pages raise issues and images particular to you, you are the best one to shape the needed queries.

Exercise 1: Painting Abundance

What makes for richness? A grove of trees? Time off? Some money in the bank?

All the above or something else? Where do you want to be and what will you be doing? Paint the life you want.

Sample Mantra: "There's no rush. Everything in its own time."

1. Your examples of abundance may be as small as new plants for your garden or as large as starting a new line of work. Whatever your thoughts, start and stay with one idea at a time. Hurrying to get many things down at once diminishes your connection to the moment at hand.
2. To portray your idea, you may choose to paint the objects you want or tools you might use to get them—if gardening, then your trowel and flower pots, for example. Or, create a symbol for the idea—the way we did in "The Painted Word" exercise, in chapter 6 (for example, an hourglass might symbolize time).
3. Add details or decoration to your images. Make them rich with embellishments.

This started with brushstrokes that suddenly had me stretching before my morning walk. The path I take in Central Park became filled with things I was trying to do with my new life in the city.

Ask Yourself

Where is this happening? Can you show something of the place you are in currently or where you see yourself in the future? You might create a setting for the objects or people—where are they, and what would you see nearby?

Do you need more room? Let the painting flow onto the next page or tear out another sheet and add it with some tape to the side, top, or bottom of the existing page. Don't be held back by some arbitrary boundary, such as keeping the book neat and tidy.

When you think you are done, take a longer look at the page. Is there anything that feels incomplete, that seems to call for one more thing? Play a game with yourself. What one thing more could you add? Is there

something already there that you can add more of? Test it out. See if it has energy.

Reflecting on Your Work

This is another exercise that can be done over and over with different results. You may find that adding ideas of abundance may be the very thing to keep a page going. The thing that lets you know when you are done will change with each page you use. Sometimes it's easy and sometimes it's hard to decide. Warning lights should go off when you feel some conflict going on or when there's a fear of messing up what you have, signaling a strong attachment to the result.

Exercise 2: Zooming In

This exercise is a kind of tool to use when you need that next idea. We often set boundaries on our perception that we aren't even aware we have. Why not, like a scientist in the lab, pick one corner or image on your page and look at it as though you were looking through a microscope lens or at the monitor of a sonogram?

For this exercise, you can go back to another page or image or create something new.

1. What if you could X-ray the image or put it under a microscope? What would you see inside—seeds, bones, organs, veins, cells, pizza pies?
2. What could be lurking underneath or coming around the corner?

Once again, I started with strokes and shapes that became a heart with cells, arteries, and veins. I didn't realize until much later that it might have had to do with my father's illness at the time. Is that my father or me in the picture? I still don't know and it doesn't matter.

Reflecting on Your Work

As with the third eye in the Hindu tradition, when we paint, we can see beyond ordinary sight. We can see past boundaries and perceive all dimensions at once. Did your energy change during this exercise? Did stretching into one area open up another? Whether you reveal what is beneath human skin or the skin of an orange, everything is fair game for keeping the process moving. Begin to question your own automatic boundaries. *What would I see if I knew no limits?*

AFTERWORD:

THE JOURNEY CONTINUES

The benefits of this journaling process deepen once you begin painting without an exercise. The painting exercises you've done up to this point have given you the tools you need to support the independent journey before you—meandering with the brush, seeing images, and adding details. Add to this arsenal anything you've discovered along the way that you like to paint. For me, I can always call on the sea for images and play with fish, shells, and flora, until the next idea comes along. One of my students liked doing circles, another, spirals. Like the dot, these shapes are a way to keep your engine going while chugging along.

Feel free to borrow ideas from anything at hand—something out the window, something on the floor. Just like the bug I once saw crawling across the floor, which inspired an insect of my own design, make whatever you find your own. Once I was painting in a class and heard someone talk about a cave. "What a great idea," I thought and started my cave without ever seeing my neighbor's. No one owns an idea. Whatever your idea or image, let it—not your head—take the lead. As if painting a dream, don't get locked into what you already know. If the brushstroke brings in a new element, a new twist to the story, follow it. Paint what you don't know, as well as what you do.

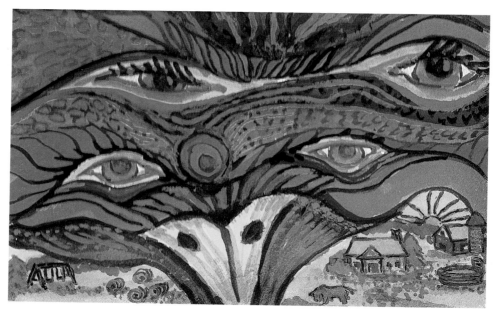

Little Worlds. *The eyes came first, turning into a strange bird-like creature. What next? Not much room . . . but enough to create a very tiny farm. Without any planning I have created a bird's-eye view.*

I found that after I had been painting in journals for many years, I suddenly was aware that the paintings or images were saying something to me. Perhaps this was after I was introduced to Carl Jung's active imagination process, but I also think I began to hear these words after I had eased my fear of making mistakes and became more in touch with my sense of humor. I began to come up with titles without working at it. I didn't force it and certainly didn't make one for every page, but it became a game I enjoyed.

One of the first and last things I talk about with students is the issue of sharing any painting they do, or the journal as a whole, with anyone else. The first question I ask is: Why would you want to? Try to pinpoint your expectations. It may seem simply that you are excited about the work and want to share it with someone, but you chance getting unwanted reactions. Others may question your process ("Why not take a real art class—you're so talented?") or be upset by your subject matter.

People look at art through the lens of their own experience. If you want to share something with someone, make sure it is someone you trust, who will be a witness to your enthusiasm and passion and not dampen it. Being a witness means they make no comment about what they see—good, bad, or indifferent—nor ask questions about the content. They just need to be there and listen to what *you* have to say.

On the other hand, be aware that once you've shown your work to someone, this might interfere with your next page. The minute you find yourself thinking about the content of your painting in terms of someone else, you've co-opted the process. Now you are no longer in a private, protected space. I've seen this happen as a student suddenly thinks of giving a painting or page to someone as a gift or starts thinking about what so-and-so would say if they saw it. You don't want someone peering over your shoulder at your work, even if they're invisible.

The same holds true with talking or sharing the process of any particular page with another person. I especially warn women, because as a gender, we tend toward sharing intimacies more easily than men. Deciding not to talk at all about what happens on a page is not about only self-protection; it's also about protecting your energy. Instead of energy going on the page, it's dissipated into the air. Bring your thoughts and feelings back to paper and brush.

I want to end with a word or two about fixing the image into matter. Whether the image comes from play, memory, imagination, or dreams, the process of transformation comes from making the image as "real" as possible and entering into a conversation with it. That is, not "real" in the sense of lifelike rendering or great craftsmanship, but recognizable as a child might make it, and with as much detail as possible. Staying abstract will not push the envelope, although abstraction is a good tool when we become stuck.

In the art room, my students build a safe environment among themselves so they may explore whatever images arise with less inhibition. They learn to talk about the process of making paintings, not the past events that may have held these images hostage. The challenge remains for them, as it does for you, to provide a safe haven inside. The more the gatekeeper-mind insidiously dictates that you paint only pretty

pictures, the more those kinds of images may elude you. As you increase your aware-ness of the mind that subjects you to judges and critics, you will come closer to freedom. Who is doing the talking? Who is watching over your shoulder? Put a face to the *who* and create a distance between you and these destroyers of impulse and intuition.

The more we can acknowledge the naysayer's presence and call him on his inter-ruptions, the less ruled by him we will be. Try, metaphorically or on paper, to hold your own hand and say, "I hear you talking and know how much you hate being ignored, but today it's going to be different." Or, choose whatever words resonate for you. Repeat them over and over like the mantras in this book. You may not believe it, but there is a place inside that is longing to hear these words.

This has to do with holding an attitude of respect and integrity toward the con-tent of the image. "What I am making is worthy of my attention and the effort of exploration, wherever it takes me." One of my students once accused me of wanting her to paint only ugly and painful things. Most participants come looking to expe-rience a larger, fuller sense of themselves—that "something" more. If that means painting darker and more powerful subjects, so be it. These images may be the very things standing in the way of your having it all. Find a way to do it playfully, with humor and understanding, not taking yourself or your work so seriously that you become captive to an iron fist of your own making. To quote an old philosophical friend of mine, "Everything matters, nothing matters."

As the poet Kahlil Gibran advises in his enduring classic, *The Prophet*, your children are not yours to keep.

Paint your pages and let them go.

RESOURCES

MATERIALS

The Watercolor Paint Box

Pelikan Watercolor Sets:
24-color Opaque
24-color Transparent

I've tried many brands, and Pelikan has the best quality for my money. Their set of twenty-four opaque cakes is a great way to get started, but if you want to spend a little more, the transparent set is a gem. The colors just sparkle.

I order them online, checking for the best price offered, either by Jerry's Artarama (jerrysartarama.com) or Dick Blick (dickblick.com).

Watercolor Brushes

Watercolor squirrel-hair mops, sizes 0–2

Raphael makes the best; however, they are very pricey and never on sale. Start out with the Harmony brand quill brush offered by Jerry's Artarama and treat yourself to Raphael later, size 0 or 1, but adding other sizes for variety.

Watercolor Short-Handled Round Sable Brushes, sizes 1–3

I call these the "detail" brushes, as they are for small work. These too can be expensive, but I go to Pearl Paint in New York and look over what they have in their sale bins and always walk away with a prize. Take a look at what your local art store has to offer. Sizes often depend upon the brand. Dick Blick offers a good selection of their own name brand, or look for Winsor & Newton.

Watercolor Paper

There are lots to choose from, depending on what you want to spend. Here are some of my favorites. All are 10" × 7" in size, acid free, 140-lb. cold press, and spiral bound. You can always try a larger size after you're comfortable with the process and ready to take a new risk.

Find the following at Jerry's Artarama or Dick Blick stores or online:

- Winsor & Newton Cotman pad, 12 sheets
 - The best price and great quality
- Canson Montval watercolor book, 20 sheets
 - I like the plain black cover on this one—it *looks* like a journal.
- Strathmore 400 Field Watercolor Book
 - 15 sheets watercolor paper
 - 15 sheets sketch paper

Although this is a book about painting, it may be helpful at some point to make note of something that happened in the course of a page, at the end of your painting session. What stopped you, how you got going again. This is a good book for jotting down such thoughts on the "sketch" or plain pages that are interspersed with the watercolor pages (*not* for sketching ideas, however). You can also use it for titles and stories that may begin to pop up as you progress.

ASKING MORE QUESTIONS

When you don't know what to do next, ask the image:

1. Why have you come?
2. Where have you come from?
3. What do you need? (Is it something I can add to the picture?)
4. What have you brought with you?
5. Are you alone?

Ask yourself:

1. Who else could be there?
2. Where is the image?
3. What is happening over, under, behind?
4. What could be coming into the picture? From the side? Above or below?
5. What could be just around the corner?
6. Can we see just part of it? The tip? The edge? The tail?
7. Is there some gift or talisman I can create that would help this image?
8. What could it be carrying, holding, pulling, cradling, swinging?

When the "body talks":
1. Where is the sensation?
2. What does it feel like?
3. What color is it?
4. What could it look like?
5. What is it next to?

When you get a feeling that stops you:
1. Can you name it?
2. Take its temperature? Hot as a ____? Cold as ____?
3. What's the consistency? Hard, soft, gooey, limp, scratchy, spiky, slippery?
4. Can you paint some of it? What color would it be?
5. If you are really stuck, check out the body.
6. If you're still frozen, do something like dots or brushstrokes.
7. Get closer; stay in one corner. See what happens.

ADDITIONAL EXERCISES AND PROMPTS

. .

Exercise: Doing the "Brush Stroke"

As I mentioned earlier, I see an analogy between swimming and the creative process. With very little technique, it's possible to float in water. The main ingredient for success is the degree to which we can relax the body. It is the same with creative expression. We need just enough technique to be able to "let go" and experience a kind of freedom to play. It always comes back to *allowing*, as opposed to controlling, the outcome. With that in mind, have some fun with this.

Sample Mantra: "This is just play."

1. Load a moistened brush with any color.
2. Lead with the tip of the brush and paint a line, starting from the left side and moving across the page to the right, twisting and turning as you go.

Hint: Make sure your brush is moist enough with paint and water so that it glides across the page.

3. Add parallel strokes above and below, experimenting with zigzag or wavy lines and different colors. As you do this, you might try to:

Vary the width of each line.

Move your brush so slowly that the line begins to shake. Continue in this manner as long as you can.

Try a faster line.

4. Vary the pressure you apply to the brush. Try pressing down and lifting up. Notice the difference it makes.

5. Finish by adding some dots to your lines. Go inside the lines themselves and in the spaces between.

I made mine all wavy lines.

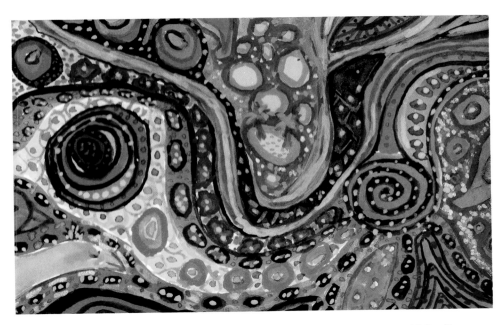

More wavy lines, shapes, and dots. Only at the end of all my dot making did I finally see images—two birds and a small palm tree island. Images come when they will.

Reflecting on Your Work

Associations may arise quickly, taking you back to early art experiences, good or bad. Just notice them without doing anything. Keep bringing the experience back to play and experimentation.

Did you notice how the brush felt in contact with the paper? Painting, beyond the obvious visual aspect, is quite a tactile activity, especially with a textured surface. How did lines differ with the speed of application? Faster may appear smoother and more evenly distributed.

Exercise: Mysterious Journey

Have you ever closed your eyes and let your finger fall blindly on a map, maybe to choose your destination? It would take an adventurous nature. As a kid, I used to do this with our atlas, not for traveling purposes but to learn about a new place and investigate it further. I so wanted to see the East and the pyramids in Egypt. Maps and atlases can inspire dreams of far-off lands and mystery.

Sample Mantra: "I'm just making this up."

Start with a color and let your brush lead the way.

1. Imagine you are taking a trip but you don't know your destination or how you will get there.
2. On this paper you will be "mapping" out your course one step at a time.
3. Begin with a "start" mark in some corner of the paper, or in true labyrinth style, start in the middle of the page!
4. Think of each line, dot, and shape you add as a road, river, railroad crossing, city, bridge, or body of water.
5. Feel free to add any other shape or image that comes to mind as you work (traffic signs, points of interest, and so on), but nothing has to be recognizable.
6. Mark the end of your trip with some mark of your choosing. It can be something personal, such as your initials, or a traditional symbol, such as a stop sign, a house, or a boardwalk "box," as if this were a game of Monopoly.

Hint: If thoughts begin to distract you, just notice what they are and try to set them aside. Remember that we are not interested in the result, but only

what happens along the way. Stay with the senses—enjoy the colors and the flow of the brush.

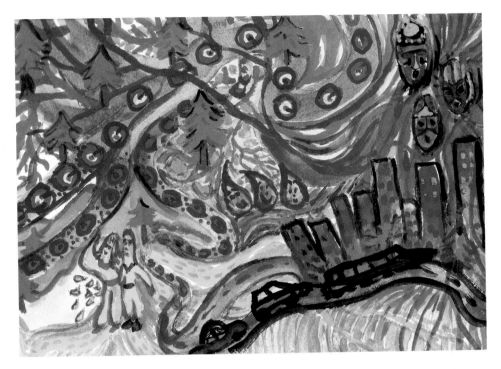

It's okay to get a little lost.

Ask Yourself

- Did anything you made suggest an image, remind you of a place, or suggest a mood?
- Is there another detail or two you could add to what you've done? Sometimes that detail can be just a dot inside or outside a line or shape.
- Is there something you did that could be repeated? Smaller? Bigger? Using another color?
- At any time, did one idea lead you to another? Is there another to follow that one?

ADDITIONAL EXERCISES AND PROMPTS

Exercise: Get Your Motor Running— An Energy Painting

The energy painting is not like the other exercises that I've introduced thus far, but is more like a tool that you can use when your engine has seized up during a painting session and you are completely frozen. When no amount of "playing" with dots, patterns, or blobs seems to help, and going slower and trying to find an image for the block has flatlined, this is the exercise you can turn to.

Sample Mantra: "I'm not making anything."

1. Go to a clean page or, better still, use a larger sheet of paper (any kind).
2. Using the mop brush, fill the page only with strokes of color without pausing.
3. Keep the brush loaded with paint and let the strokes be haphazard. Let your hand be in constant motion going from paint to paper.

Hint: The intention here is not to thoughtfully place strokes but to paint as loosely as you can while keeping the color bold. We are working to get the energy freed up—in body, mind, and brush.

4. Keep painting until you run out of steam. It's all right to keep painting over the same strokes.

Did you feel yourself loosen up or did you remain tight the entire time, fighting to control the outcome? You may need to do another one or several. What thoughts were going through your mind? Can you use any of them as you return to your previous page?

Reflecting on Your Work

Don't worry if this didn't do much to loosen you up this first time. This too will take practice. Letting go of outcomes can be a continuous challenge.

Prompt: The Shape of Fear

Consider this as taking "The Painted Word" exercise in chapter 6 one step further. There is never just one fear to face in a lifetime, and our fears change as we do. Away on a vacation by myself in the Virgin Islands, I realized I still had an underlying fear of the dark. I say *underlying* because it only seemed to arise in certain situations, usually when I was away from home. My first memory of it occurred on a sleepover in high school. One of my best friends had recently moved to a very rural area with no streetlights. I awoke during the night in a panic and somehow fumbled my way to the bathroom, where I washed my face and calmed back down. That was it. Ten years later, as I entered Tom Sawyer's Cave in Orlando with my young family, I felt the same panic arise. Much to my embarrassment, I had to back out.

After my Virgin Islands trip, I did a painting in my journal, then a larger painting, and later a mask, all about the night—all about being in the dark. I started with purple and black strokes that became the sky, added planets

and stars and finally the two creatures that had frightened me that one evening as I walked on a hilltop in Saint Croix—two big, black hounds. I ended all this art making by creating my own dark image, which I called *Queen of the Night* after the character in Mozart's *Magic Flute*. Powerful, fearsome, and, I think, triumphant.

Name the fear and give it a face.

Prompt: The Cosmic Egg

Whether we look to fairy tales, creation myths, or biology, the egg is a place of beginning. The egg, and contents within, is *the* vessel of possibility and potential. In Chinese myth, the world is an egg that breaks in half to form earth and sky. Egyptian legend has the god Thoth laying an egg while in the form of the sacred ibis, and in later versions, laying a golden egg.

Make your own egg or eggs. Decorate your egg like the Ukrainian *pysanka*—full of lines and shapes, a method that predates Christianity when the egg was a magical object—or bejewel it in the style of the House of Fabergé. Crack one open. What would you find—a bird, a dinosaur, or the primordial ooze? Create your own myth.

Prompt: Helper Figure

Does something or someone on your page need help? Send in a repairman. Who is needed—a plumber, a carpenter, an electrician, or a shaman? What tools does he bring with him? Perhaps you could play with adding a talisman for protection. Borrow from the world—make an amulet, a fetish, a lucky charm.

In the midst of this bizarre scene, a carpenter arrives with his tool kit at hand.

ADDITIONAL EXERCISES AND PROMPTS

NOTES

· ·

Epigraph

1. Wendell Berry. *Standing by Words: Essays*. Berkeley, CA: Counterpoint, 2011.

Introduction

1. MedicineNet.com. medterms.com/script/main/art.asap?articlekey=11490. Accessed June 14, 2012.

Chapter 1: Keeping a Visual Journal

1. Brenda Ueland. *If You Want to Write: A Book about Art, Independence and Spirit*. N.p.: BN Publishing, 2010.
2. James E. Zull (2004). "The Art of Changing the Brain." *Educational Learning* 62 (1): 68–72.
3. Bogdan Draganski et al. (2004). "Neuroplasticity: Changes in Gray Matter Induced by Training." *Nature* 427 (6972): 311–2.
4. Craig Aaen-Stockdale (2006). "Clowning About in Brain Scanners." *Psychologist* 19 (7): 414–5.

Chapter 2: The Mind-Set: "I" Is for Improvise

1. Stephen Nachmanovitch. *Free Play: The Power of Improvisation in Life and the Arts*. Los Angeles: Jeremy P. Tarcher, 1990.
2. Sir Ken Robinson. "Do Schools Kill Creativity?" Speech at TED Conference, Monterey, CA. February 2006. www.ted.com/talks/ken_robinson_says_schools_kill_creativity.html.

3. Nachmanovitch, *Free Play*, p. 55.
4. Charles J. Limb and Allen R. Braun (2008). "Neural Substrates of Spontaneous Musical Performance: An fMRI Study of Jazz Improvisation." *PLoS1* 3 (2). doi:10.1371/journal .pone.0001679.s005.
5. Nick Zagorski. "Music on the Mind." *Hopkins Medicine Magazine*. Johns Hopkins University, Spring/Summer 2008.
6. Nachmanovitch. *Free Play*, p. 75.

Chapter 3: Getting Started
1. Bob Dahlquist. "Gestalt Theory: Equilibrium." *Before and After Magazine*, 2008.

Chapter 4: Coloring 101
1. Georgia O'Keeffe. *Some Memories of Drawing*. Albuquerque: University of New Mexico Press, 1988.
2. Crayon & Color Info. http://www.crayola.com/about-us/crayon-chronology.aspx. Accessed November 25, 2012.

Chapter 5: The Unplanned Painting
1. Edward Hill. *The Language of Drawing*. Englewood Cliffs, NJ: Prentice-Hall, 1966.
2. Janet Rae-Dupree. "Innovative Minds Don't Think Alike." *New York Times*, December 30, 2007.
3. Rex E. Jung et al. (2010). "White Matter Integrity, Creativity, and Psychopathology: Disentangling Constructs with Diffusion Tensor Imaging." *PLoS1* 5 (3): e9818. doi:10.1371/journal.pone.0009818.
4. Patricia Cohn. "Charting Creativity: Signposts of a Hazy Territory." *New York Times*, May 7, 2010.

Chapter 6: The Language of Images
1. Bert Cardullo. "The Films of Robert Bresson." *Aesthetic Asceticism: The Films of Robert Breson*. London: Anthem Press, 2009.
2. Jill Bolte Taylor. *My Stroke of Insight*, 1st ed. New York: Viking Penguin, 2008.

Chapter 7: Oops, Ouch, and Aha!

1. Dan Millman. *Body Mind Mastery: Training for Sport and Life.* Novato, CA: New World Library, 1999.
2. Mark Jung-Beeman (2004). "Neural Activity When People Solve Verbal Problems with Insight." *PLoS Biology 2* (4). doi:10.1371/journal.pbio0020097.sg001.
3. Ibid.

Chapter 8: Letting Go

1. John Heider. *The Tao of Leadership: Lao Tzu's Tao Te Ching Adapted for a New Age.* Atlanta, GA: Humanics New Age, 2005.
2. Taylor, *My Stroke of Insight,* p. 19.
3. Joseph LeDoux. "Overview. Emotion, Memory, and the Brain: What the Lab Does and Why We Do It." LeDoux Laboratory: Center for Neural Science, New York University. cns.nyu .edu/ledoux/overview. Accessed October 29, 2012.
4. Monty McKeever. "The Brain and Emotional Intelligence: An Interview with Daniel Goleman." Tricycle.com, May 18, 2011. tricycle.com/blog/brain-and-emotional-intelligence-interview-daniel-goleman.
5. M. D. Lieberman et al. (2007). "Putting Feelings into Words: Affect Labeling Disrupts Amygdala Activity in Response to Affective Stimuli." *Psychological Science* 18: 421. doi:10.1111/j.1467-9280.2007.01916x.

Chapter 9: Myth, Magic, and Psyche

1. C. G. Jung. *The Structure and Dynamics of the Psyche,* in *The Collected Works of C. G. Jung,* vol. 8. Princeton, NJ: Princeton University Press, 1970.
2. C. A. Burland. *Myths of Life and Death.* New York: Crown Publishers, 1974.
3. C. G. Jung. *Two Essays on Analytical Psychology,* 2nd ed. Princeton, NJ: Princeton University Press, 1966.
4. Sara Corbett. "The Holy Grail of the Unconscious." *New York Times Magazine,* September 20, 2009.
5. Pamela Weintraub (2012). "Discover Interview: Jaak Panksepp Pinned Down Humanity's 7 Primal Emotions." *Discover Magazine,* May 31, 2012.
6. Arthur Niesser (2010). "Neuroscience and Jung's Model of the Psyche: A Close Fit." International Association for Analytical Psychology (IAAP) Website. January 28, 2010. http://iaap .Org/Congresses/Barcelona-2004/Neuroscience-And-Jungs-Model-Of-The-Psyche-A-Close-Fit.Html.

Chapter 10: Working the Edge

1. Anne Morrow Lindbergh. *Gift from the Sea.* New York: Pantheon Books, 1991.
2. Charlene Spretnak. *Lost Goddesses of Early Greece.* Boston: Beacon Press, 1992. In the original version (prior to the Hellenic Age, in the fourth century), there was no rape or capture of Persephone. The decision to go below was made by the young goddess herself after witnessing the souls of the dead wandering aimlessly about. Unable to adapt to their new state, they hovered over their homes lost and in despair. Persephone offers to leave her mother and take on the role of guide, initiating the dead into their new world.
3. Joseph Campbell. *Transformation of Myths through Time.* New York: HarperPerennial, 1999.
4. Clarissa Pinkola Estés. *The Creative Fire.* Boulder, CO: Sounds True Recordings, 1991.
5. D. Mobbs et al. (2003). "Humor Modulates the Mesolimbic Reward Centers." *Neuron* 40: 1041–8.
6. Karuna Subramaniam et al. (2009). "A Brain Mechanism for Facilitation of Insight by Positive Affect." *Journal of Cognitive Science* 221 (3): 415–32.

Chapter 11: It's Over When It's Over

1. Ursula K. Le Guin. *The Left Hand of Darkness.* New York: Ace Trade, 2000.
2. Mandy Kendrick (2009). "Tasting the Light: Device Lets the Blind 'See' with Their Tongues." *Scientific American*, August 13, 2009.

SUGGESTED READING

Allen, Pat B. *Art Is a Way of Knowing.* Boston: Shambhala Publications, 1995.

Carter, Rita. *The Human Brain Book.* London: Dorling Kindersley, 2009.

Cassou, Michele, and Stewart Cubley. *Life, Paint and Passion.* New York: G. P. Putnam's Sons, 1995.

Gelb, Michael J. *How to Think Like Leonardo Da Vinci: Seven Steps to Genius Every Day.* New York: Delacorte, 1998.

Gladwell, Malcolm. *Blink: The Power of Thinking Without Thinking.* New York: Little, Brown, 2005.

Leonard, Linda. *The Call to Create: Celebrating Acts of Imagination.* New York: Harmony Books, 2000.

McConeghey, Howard. *Art and Soul.* Dallas: Spring Publications, 2003.

Nachmanovitch, Stephen. *Free Play: The Power of Improvisation in Life and the Arts.* Los Angeles: Jeremy P. Tarcher, 1990.

Restak, Richard. *The Secret Life of the Brain.* Washington, DC: Joseph Henry Press, 2001.

Robertson, Seonaid. *Rosegarden and Labyrinth: A Study in Art Education.* Dallas: Spring Publications, 1989.

Taylor, Jill Bolte. *My Stroke of Insight.* 1st ed. New York: Viking Penguin, 2008.

ACKNOWLEDGMENTS

Long before I began to search for a more authentic painting process for myself, I was always on the lookout for a freer, more expressive way to approach art with my young students. One of my most exciting discoveries was the book *Doing Art Together*, written by art educator Muriel Silberstein-Storfer and based on her parent-child classes at The Metropolitan Museum of Art. I was so stirred by the explorative art experiences she provided for the very young that I called the museum and left my name and number, and to my amazement, she called me back! I loved the fact that she didn't feel she was teaching art as much as helping children to grow and know their world. Like myself, she saw the potential art making had for personal growth, at any age. Now I believe it even more.

As so often happens in a teacher's life, the students you teach and the profession itself may guide you to take a deeper look at your own process. You can't teach others to take chances if you're not doing it yourself. I'd like to thank my students for their courage in the studio and for making me a better (and funnier) teacher. The other people in my life who supported my creative searchings and modeled individualized approaches were friend and artist Anthony Velonis, my voice teacher Gary Ledet, and artist and teacher Florence Hurewitz.

This book was based on five essays or "letters" I wrote to my students in the early days of teaching the unplanned-painting approach. I wanted to send them home with words that might help them reflect and better understand the journey they had taken during class. In order to turn those first pages into a complete book. I met and worked with some

extraordinary people. I'd like to thank my fellow nonfiction writers at Mediabistro for their feedback and encouragement, Christa Bourg for her editing and insightful guidance these last three years, my agent Laurie Abkemeier for her response to the book's message of hope, and my editors Sara Carder and Joanna Ng at Tarcher/Penguin. Their vision and enthusiasm made it possible for my book to have the color illustrations I envisioned from the start. My thanks to copyeditor Jane Ludlam.

I am so grateful to Stephen, my dearest friend, for listening and listening, reading and editing, and for using his fine graphic skill to ensure my illustrations were the best reflection of the original paintings. Love and many thanks to my family and friends for their continued support (and for listening and listening).

INDEX

.

Expanded
& Updated

The definitive, 4th edition of the
New York Times bestseller

DRAWING ON THE RIGHT SIDE OF THE BRAIN

A course
in enhancing
creativity
and artistic
confidence

BETTY EDWARDS

AN EXPANDED AND UPDATED EDITION OF
THE CLASSIC DRAWING BOOK THAT HAS
SOLD OVER 2 MILLION COPIES.

"Not only a book about drawing, it is a book about living.
This brilliant approach to the teaching of drawing . . . should
not be dismissed as a mere text. It emancipates."
—*Los Angeles Times*

978-1-58542-920-2

$19.95

THE
ARTIST'S WAY
FOR
PARENTS

Raising
Creative
Children

JULIA CAMERON
bestselling author of *The Artist's Way*
with EMMA LIVELY
Foreword by Domenica Cameron-Scorsese

An international bestseller, *The Artist's Way* has served
as an invaluable guide for millions of readers
seeking to live more creatively.

978-1-58542-146-6

$16.99